SAGRADO

Joanne —

May you always seek
out the
sacred spaces of
the world!

SAGRADO

A PHOTOPOETICS ACROSS THE CHICANO HOMELAND

NARRATIVE **Spencer R. Herrera**

PHOTOGRAPHY **Robert Kaiser**

POETRY **Levi Romero**

FOREWORD **Luis Valdez**

UNIVERSITY OF NEW MEXICO PRESS

ALBUQUERQUE

Library of Congress Cataloging-in-Publication Data

Herrera, Spencer R., 1972–

Sagrado : a photopoetics across the Chicano homeland / narrative by Spencer R. Herrera;

photography by Robert Kaiser; poetry by Levi Romero; foreword by Luis Valdez.

 pages cm — (Querencias)

In English.

Includes bibliographical references.

 ISBN 978-0-8263-5354-2 (pbk. : alk. paper) — ISBN 978-0-8263-5355-9 (electronic)

1. Mexican Americans—Mexican-American Border Region—Social conditions. 2. Mexican Americans—Mexican-American Border Region—Pictorial works.
3. Mexican Americans—Mexican-American Border Region—Poetry. 4. Mexican-American Border Region—Social conditions. 5. Mexican-American Border
Region—Pictorial works. 6. Mexican-American Border Region—Poetry. I. Kaiser, Robert, 1950–, photographer. II. Romero, Levi, author. III. Title.

 F787.H468 2013

 972'.1—dc23

 2013001693

COVER, INTERIOR DESIGN, AND COMPOSITION: Catherine Leonardo

Composed in 10.4/13.4 Adobe Garamond Pro

Display type is Charlemagne Std, Helvetica Neue, and Adobe Garamond Pro

To Jessica, who helped me find what I was searching for

For my lovely wife, Nani Kaiser
My Irresistible Force

Para Mercedes y Primavera
que gocen de su cultura y su querencia
y de lo nuestro
lo sagrado

Contents

FOREWORD by Luis Valdez ix

PROLOGUE x
"Destinations" 1

CUANDO VINO EL ALAMBRE, VINO EL HAMBRE 2
"En este país y en el mío" 12

SI DIOS QUIERE 23
"Epigraph" 32

DIME CON QUIEN ANDAS . . . 44
"Like a Good Golden Drink" 52
"Still Life #3" 57
"turn, turn, turn" 62
"Ascension" 68

MI VIDA LOCA 70
"Los Heroes" 76
"Familia" 80
"No hay honor más dulce" 83

EL NORTE MÁS ALLÁ 85
"Taos Nicho" 89
"Daddy's Old Trucks" 98
"I Breathe the Cottonwood" 105

UN PUÑO DE TIERRA 106
"Years after my father died" 113
"Descanso" 119
"As It Will Be Without Him" 123

CUANDO LLEGUEMOS 124
"Botes de diez" 137

EPILOGUE: IN SEARCH OF PANCHO VILLA 138
"Pancho Villa's Prayers" 140

NOTES ON THE PHOTOGRAPHS 141

RECONOCIMIENTOS 143

Foreword

The search for identity in Chicano culture is in many ways indistinguishable from the quest for a homeland. This is equally true of immigrants from all over the world, of course, but Mexican Americans can genetically claim cultural links to the most ancient inhabitants of this hemisphere. While many of our ancestors arrived with the conquistadores, a great many more were already here, in the Americas. Whose homeland is it then, really? And why is the Chicano so compelled to identify the American Southwest as the mythical Aztlán, original homeland of the nomadic Mexica who headed south sometime in the twelfth century to eventually found their Aztec capital of México, Tenochtitlán, in Lake Texcoco around 1325 BCE? These questions and many others lie embedded at the heart of this remarkable book.

Sagrado: A Photopoetics Across the Chicano Homeland is nothing less than a kaleidoscope utilizing a lens of three mirrors to break apart and recompose its images. The personal narratives of Spencer R. Herrera, the photography of Robert Kaiser, and the poetry of Levi Romero complement each other and form a poignant search to reconstruct the broken shards of the Hispanic American experience. Fittingly, much of the exploration begins and ends with the desert landscape. The focal point is New Mexico, near Las Cruces, where this project was born, not far from El Paso, Texas, and Juárez on the Mexican border. Yet we soon find ourselves exploring the topography of the Chicano psyche, crisscrossing time and space to examine what is there or not there in the splintered images of ourselves. We quickly learn that *lo sagrado*, the sacred, cannot exist apart from *lo profano*, or at least *lo mundano*. The borderlands are replete with examples of profane or mundane tokens turned sacred by the willful intercession of human faith, from the roadside crosses at the very spots along the highways where someone died to a *curandera*'s miraculous use of a simple chicken egg to cure the illness of her grandchild.

The desert landscape of New Mexico evokes eternity in the midst of inescapable mortality. Every day from horizon to horizon, the fecund sun vaults over the mountains, orbiting over the Río Grande, provoking the arid but fertile earth of the borderlands, demanding a culture that matches its solar persistence. What has sprouted is an unbroken chain of human settlements spanning centuries of longing, defined by the ephemeral dreams of wayfarers across the vastness of its territory. The oldest living pueblos in the United States are to be found in New Mexico, together with the greatest diversity of Native American tribes. This undeniably is the cultural uniqueness of this ancient land. It is the basis of what makes it sacred. The tragedy is that the most recent arrivals have profaned the open spaces of nature with fences and borders. Thus, as Spencer Herrera so aptly observes: *Cuando vino el alambre, vino el hambre.*

Like geological strata, the layers of human history are still visible in New Mexico. Traditional nineteenth-century Mexican *charrerías* coexist with contemporary car shows by slick-haired Chicano lowriders. The Hispanic descendants of Don Juan de Oñate, the last conquistador and colonial founder of Nuevo México in 1598, coexist with survivors of the indigenous victims of Acoma Pueblo, which Oñate devastated in his effort to quell rebellion. Today Mexican Americans coexist with Anglo Americans, who began to arrive even before the war with México in 1846–1848, which led to México ceding the territory to the United States under the Treaty of Guadalupe Hidalgo and, later, the Gadsden Purchase. Yet no one today would dare claim that history in the borderlands has come to a standstill. That imaginary line in the desert called the Mexican border is still bleeding like an open wound. Silent pain is evident in the sun-baked face of Carlos Luis, the Yaqui "Pancho Villa," whose photopoetic portrait speaks to the stoical endurance of our indigenous bloodroot across the last five hundred years.

Ironically, in spite of the vast landscape it traces, this book is an intimate journey into the solitude of the Chicano labyrinth. There in the deep maze of the individual heart is the collective homeland we all seek.

—Luis Valdez

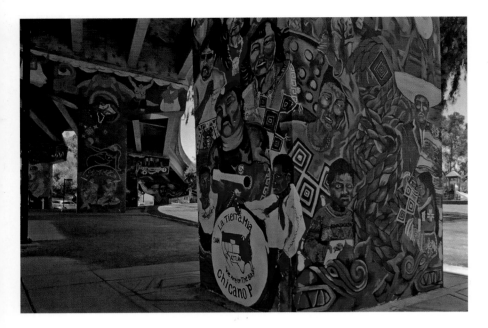

Chicano Park in Barrio Logan, San Diego, California, and El Teatro Campesino in San Juan Bautista, California, and Resistencia Bookstore in Austin, Texas, are just some of the Chicano sacred spaces that emerged from the Chicano movement of the late 1960s and early 1970s. Such venues were instrumental in providing a place where Chicanos could seek refuge and where their cultural identity was allowed to thrive in a public forum. This had not always been the case for people of Mexican descent living in the United States. With the signing of the Treaty of Guadalupe Hidalgo in 1848 to end the U.S.-Mexican War, Mexican Americans began to lose much of their land and power and, subsequently, were relegated to a second-class status. One hundred years later, after the end of World War II, Mexican Americans began to make strides in achieving social equality. Many had proven their allegiance and love for their country, some with their lives. Through their shared sacrifice Mexican Americans were finally beginning to carve out a space as part of the American social fabric. The generations preceding today's Chicanos suffered much along the way, but not all was lost.

To triage the cultural hemorrhaging required an introspective look into who we were and where we came from. With the onset of the Chicano movement of the 1960s, we began to explore these two questions and many more. One of the major cultural developments born out of the Chicano movement was the resurgence of the notion of Aztlán, the mythical homeland of the Aztecs and the cultural origin of Chicano identity. Many scholars believe that Aztlán lies in the Southwest United States. For this reason, Chicanos have come to embrace the idea that the Southwest is our ancestral homeland. Ironically, it is the space we lost and yet currently occupy.

The idea of space has been an issue that Mexicans and Mexican Americans have grappled with since before the battle for Texas independence in 1836. It is a complex matter for Mexican Americans, who not only remember the Alamo, but are never allowed to forget that we "lost" and that the conquerors write the history. But people fail to recall that we fought for both sides, México and Texas. Either way, it was a no-win situation for Mexican Americans. The private land holdings we lost after the U.S.-Mexican War, the erosion of the land and water rights, the historical erasure of our communities and oral traditions, the diminished value of the Spanish language, and the deliberate eradication of our sacred spaces are all examples of the slow dissolution of our Chicano culture that has taken place for almost two hundred years.

Prologue

La plaza, *la resolana*, and *el camposanto* are traditional sacred spaces that have been mainstays of Chicano culture for generations. Their social and cultural significance have been instrumental in defining Chicano cultural space. However, their communal impact has slowly faded away under the pressure of cultural assimilation. These spaces were once key community gathering places where people would meet, plan, celebrate, share *chisme*, honor loved ones, or just simply pass the time. They were epicenters of Chicano culture. They helped preserve the social fabric of our people and created a link to the rest of Hispano America. In tucked away corners across the Southwest United States these traditional Chicano sacred spaces still exist today, but to a much lesser degree or in a more commercialized form than their historical precedents.

Cultural survival has forced Chicanos to adapt and create new sacred spaces. Chicano culture has endured because we have allowed our notion of sacred space to evolve. Today a sacred space, as defined by Levi Romero, can exist almost anywhere where two or more people gather in the name of community. From *el parque* to the corner store, the roadside *descanso* to the homemade altar, the cantina to the mariachi Mass, and all the countless places in between, sacred spaces can be found for those who seek them out. Whereas before our sacred spaces defined us, we now define our sacred spaces. *Lo sagrado lo llevamos por dentro, y cuando nos reunimos con lo nuestro, lo compartimos, y así siguen sobreviviendo nuestras tradiciones y cultura*. It has been a struggle and a long journey to reach this point, but we can now say that we have not lost ourselves. We have just reinvented who we are. These sacred spaces cannot be stolen, commercialized, or disregarded, for we carry them within to share with our community. Every time we pray, celebrate, sing, dance, cry, and break bread together we reconnect with who we are as a community. The sacred space is within us.

La Soledad: Un Trip into the Chicano Labyrinth

When I was sixteen years old I spent six weeks in a small rural village in Michoacán, México, called La Soledad. Solitude—the name says it all. I had been to México a handful of times before, a visit to relatives in Puebla, a family vacation in Acapulco, and along the border near the lower Texas valley. During these trips I always felt like a tourist or the *pocho* cousin who did not speak Spanish. I was never a Mexican in México, at least by Mexican standards. Who was I to argue? After all, I was a monolingual English speaker.

Prior to these visits I had never doubted my Mexicanness. I was also American by birth and through culture. I had not thought much of this duality, nor did it seem to bother me. My father, who was born in Texas, as were his maternal great-grandparents, always made it clear: we were Mexican and proud of it. He seldom explained why we should be proud, but you could feel he meant it when he said it. He did, however, show us through his actions what it meant to be Mexican. As I learned from my father, being Mexican was not about where you were born, but about how you lived your life.

When I was young it seemed as though my father was always taking my brother and me to some sort of cook-off—menudo cook-off, fajitas cook-off, *tripas* cook-off. At these events, we ate often and we ate well. But there was always more than just food at these social gatherings. There was *compadrazgo* complete with *chistes*, *carrilla*, and *amor*. There were also *borracheras* accompanied by more chistes (dirty ones), *carcajadas*, Tejano music defined by its eclectic mix of accordion, trumpets, and keyboard, dancing with the occasional *gritos* yelped out, mediated arguments, and the sudden need to marinate all meat with beer.

At these events, I wasn't just my father's son. I was *mijo* to all of my father's friends. I was everyone's son, and so was my brother.

> Mijo, go get us some ice.
> Mijo, get me and your *tío* a beer.
> Are you planning to go to college, mijo? Good, make us proud and get your education. Nobody can ever take your education away from you.

I could be anybody's son and was treated as such. I understood why my father was proud to be Mexican, because so was I. However, my unabashed pride did not last forever.

Your lowcura is what makes you who you are.

—Levi Romero

Once I understood that I was not viewed as a Mexican in México, my sense of being and feeling Mexican perplexed me. After all, I looked Mexican, my last name is of Hispanic origin, my family was originally from México, and I certainly felt Mexican. As I grew older I gradually began to realize what made me American and not Mexican to the Mexicans who lived in México. It was not merely the fact that I was born in the United States, although that played a part. It was that I did not speak Spanish like a Mexican. In fact, I spoke very little Spanish up until the summer I spent in La Soledad. It was during this trip when I began to improve my Spanish substantially and also to learn more about what it meant to be Mexican. It was also during that time I learned I was indeed Mexican, but from this side of the border, *un mexicano de este lado*.

Eventually, I learned never to say that I was American while traveling in México. Instead, I would call myself Tejano. Mexicans understand and respect that. Being that México is regionalized, people easily identify with the part of México they are from. In addition to *el orgullo* I felt for being Mexican, I was also proud of being Tejano. However, it would not be until years later that I would learn what it meant to be Chicano.

While I was living in Michoacán during that summer, many people became fascinated with my story. They didn't quite understand how I was both Mexican and American. How did I get to the United States? How was it possible that my parents were also born there? Many Mexicans had the notion that the United States was black and white, not brown. To them, Mexicans were immigrants in the United States, not born citizens. When you combined their preconceived notions of what Americans looked like with my brown skin, my American first name and my Hispanic surname, my perfect English, and my broken Spanish, I suspect many Mexicans didn't know what to think of me. But as for me, I was coming into a consciousness of who I was and who I wanted to be. I wanted to recover my Mexican identity from its almost comatose state. Yes, my family and I shared certain elements of what I considered to be Mexican culture. But I didn't understand the language of my parents and grandparents when they spoke of family secrets that I could not decode. I did not know the history of my family and people in the United States or in México. Due to all of these circumstances, none of which were of my doing, I had become culturally and linguistically lost.

As I traveled by bus deep into the interior of México, I began to see and understand who I was. This would only be accomplished by choosing to enter into my own labyrinth. Tomás Rivera, an icon of Chicano literature, understood the value of the search for oneself. In writing about the Chicano experience, he argued that Chicanos would be able to recover their cultural identity by delving into a labyrinth, by going into the deepest darkness of their existence, where they are alone with themselves. It is there, in that pit of solitude, that they can hear the voices of their ancestors calling back to them: *"No nos olviden,"* "Don't forget us," they cry out.

La soledad, or solitude, can also mean loneliness, a lonely place, or the state of orphanage. All of these names were appropriate in their own way. When I first arrived in La Soledad, the town had no streetlights. There was no running water, only well water. There was a single dirt road that split the town in two, with adobe houses scattered on both sides. Rock walls lined the dirt road that divided small plots of *maíz*; corn was and continues to be the main staple of the people. Upon entering the town, to the left, there was a hill that formed the wall of an artificial lake stocked with bony perch, another main food source of the poor there. To the right, in the far distance, began the stretches of a beautiful mountain chain marked by green vegetation. This was the physical nature of La Soledad. The literal nature held much more true to its name.

To get to La Soledad one must take a long bus ride through the lush countryside from Morelia, the state capital, to Pátzcuaro, a Purépecha community, and finally to La Soledad. If there are no buses leaving that day for La Soledad, then the back of a dump truck, as happened in my case, would do. Upon arrival I met my host family, who welcomed me into their home for the next six weeks. By U.S. standards they were poor. The house was made of adobe, with dirt floors and colorful walls. With only a few rooms, the house was full. There lived the grandparents, some of their adult daughters and nieces, and many young children. The elderly grandfather was the only man living in the home. I soon realized that there were few adult men living in the town at that time. I came to find out they were working in the strawberry fields of Oxnard, California. This was their reality. The women raised the children while their men worked *en el otro lado* for long stretches of time. In some cases they were absent for years, but managed to send money back home to feed and clothe their families. It was here, in this cramped adobe house, living among aging grandparents, hardworking women, and barefoot children, that I would learn about solitude.

Octavio Paz, one of México's most prolific authors and intellectuals, in his landmark book of essays *El laberinto de la soledad* (*The Labyrinth of Solitude*, 1950) examines the search for identity that often takes place within oneself or, as he describes it, in solitude. It is interesting that the book is about the search for Mexican identity and yet the first chapter, "Pachucos y otros extremos" ("Pachucos and Other Extremes"), focuses on the Mexican American youth of the 1940s in Los Angeles. In his detailed physical and psychological description of these pachucos, who were also known as zoot suiters, Paz declares that they were orphans who lacked *valedores* (protectors) as well as *valores* (values). According to Paz, they had lost their entire cultural inheritance: language, religion, customs, and beliefs. However, despite this erosion of cultural mores, Paz claims that these pachucos were still Mexican, albeit of an extreme form that any Mexican can arrive at. When I arrived in La Soledad, some might have thought I was without such values. But this was not the case. I had valedores who instilled in me a sense of valores. *Nunca fui huérfano*; I just had to search for myself within the depths of my own labyrinth, in solitude.

Paz's ideas were and continue to be insightful and

controversial. If Chicanos were orphans it was because we were never adopted by México; we did not choose that fate. This is why we have had to create our own identity forged from three cultures: indigenous, Mexican, and American. To balance these cultures has not always been easy. Many times we have been denied acceptance by each of these groups, and yet we continue to claim them as part of who we are, despite the painful rejection. Being orphaned hurts. Eventually, you learn to use the pain to build something new, something that is uniquely yours.

Solitude, loneliness, *la huerfandad*, this is how it all begins to make sense.

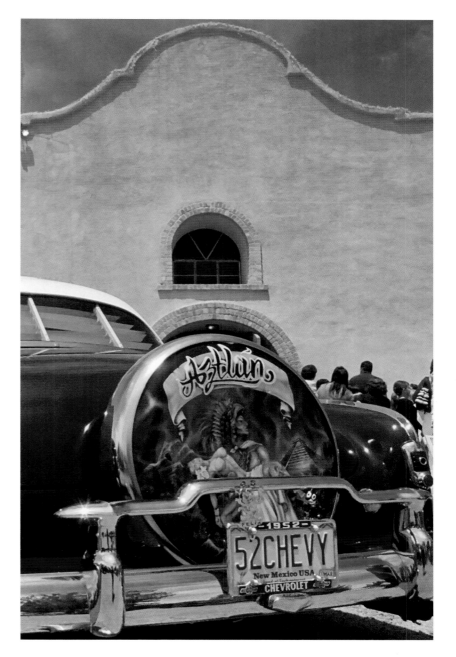

My grandfather died alone in a rented room in Orizaba, Veracruz. He always traveled back and forth between Houston, where we lived, and Veracruz, his native home. Like thousands of Mexicans before him, he came to the United States to seek work. This was where he met my grandmother, raised a family, and made his living. Despite his new life full of promise in the United States, his heart belonged to México. México was the mistress he could never abandon. It was from that faraway place that his spirit, one night, came calling back for us.

When my mother got the call early one morning, she already knew something had happened and that it concerned her father. The night before, as she had lain in bed, a noise had awakened her in her already uneasy state of sleep. She heard my grandfather's walker slowly shuffling down the hallway and then his voice whispering out to her, "Yolanda, Yolanda." My grandfather may have died alone in a rented room, but his soul was not in a state of solitude; he died among his people.

It is a Mexican custom never to leave the body alone before burial. My grandfather's body was cared for until my mother could arrive in Orizaba and have him properly buried. She did not forget him. We could not let his memory fade into death. We would not forget that we are connected to a past, a place, and people who gave us everything that we needed to create a future generation who could then do the same for us and for our children. We are all bound together, one by one, promising never to forget from whence we came. It is said that someone is never really gone as long as we remember his or her name. "No nos olviden," their voices cry out to us.

Years later my family and I would visit my grandfather's grave in the cemetery in the hills outside Orizaba. The plot was difficult to find. Mexican graveyards are seldom manicured like American ones. It is the duty of the family to maintain the plot and keep it neat. We felt a sense of relief when we found his among a maze of poorly marked ones. We cleaned it up and made plans to provide a nicer headstone so that we could locate it more easily next time. As we sat in the quiet existence with a soft breeze running through the wildflowers and overgrown grass, we enjoyed the peace of just resting and being thankful that we had found what we were searching for. I don't think we would have found it alone. La soledad, as it turned out, did not have to be such a lonely place after all.

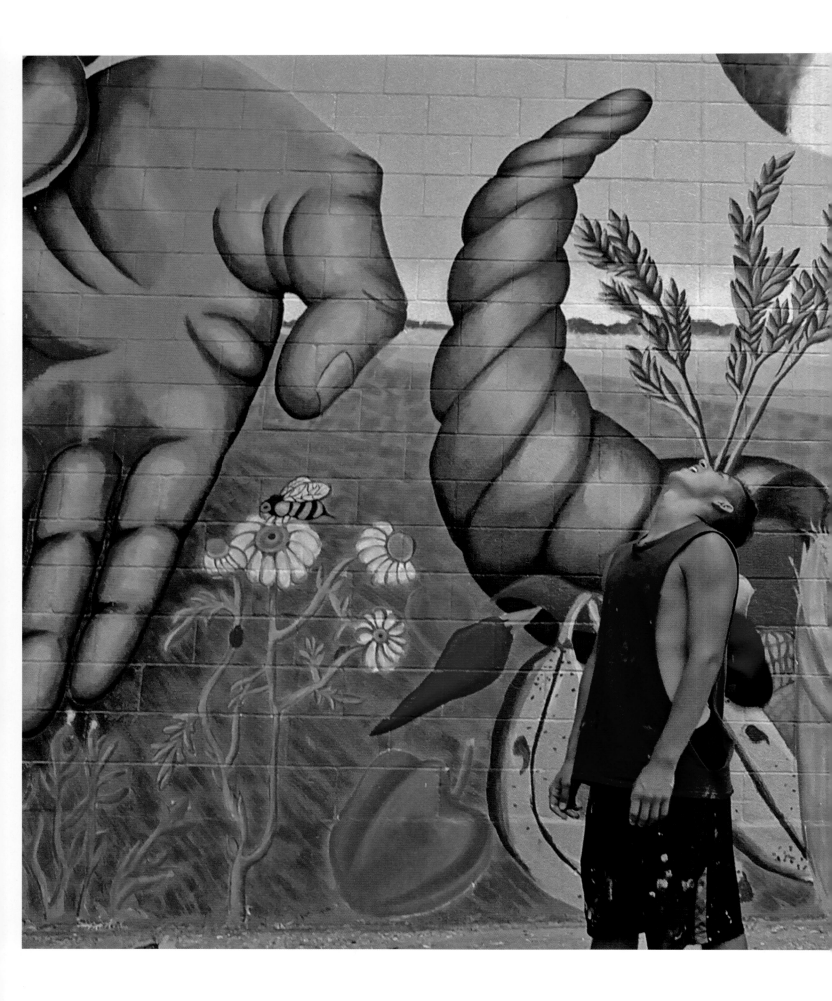

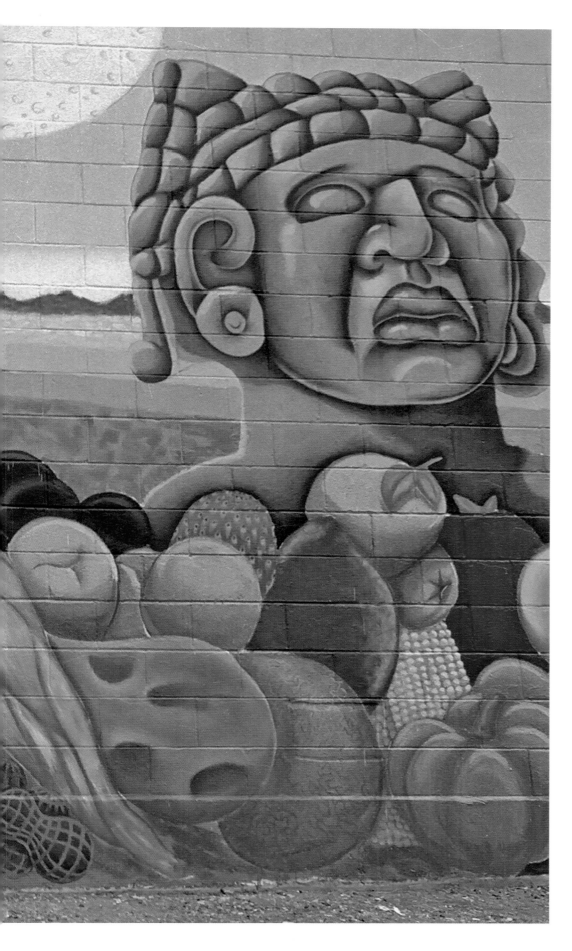

Destinations

tonight the stars
are bright and plentiful
and with our necks craning
up toward the sky

we stand attempting to identify
the constellations and trying
to distinguish
the satellites
from the jets and the stars

I planted the last of the garden today
chile, alverjón, cebolla, rabanitos

several days ago it was the *maíz*
melones, sandías, calabacitas

a warm breeze is blowing
across the orchard
there has been mention of ghosts
and spirits of relatives
who come to visit

that they move
through the fields
stooped over like burma grass
in the wind

las grullas will fly
over the village tomorrow
northward, their long necks
piercing the sky

Cuando vino el alambre, vino el hambre

We want to ask God for forgiveness for the injustices and violence that this fence represents. Somos todos quienes somos culpables. Pero también esta frontera es bella. There's cause to rejoice. Desde San Diego a Brownsville hay fe.

—Bishop Ricardo Ramírez

When I think of México, several images come to mind. I think of the good, honest, hardworking people I have met there during my travels, people who give of themselves unselfishly. I recall the heartwarming nostalgia I would feel when I saw families spending time together in the plazas and the parques. I think of the rich aroma that fills the air from the taco and *torta* stands. When I walk along México's ancient ground I feel as though my feet have sprung roots and with each step the root system expands deeper into the earth. I feel a connection to a place and a people that I seldom feel in my home country. This is the México I fondly remember, a place I have not visited for some time, but one that lives strongly in my memory.

But when I think of the border, I admit, I don't think of the same México. I think of trash, pollution, crime, murder, femicide, corruption, poverty, and just too many people trying to scrape out a living in one of the harshest places on earth to raise a family with dignity. I remind myself it's not their fault. Capitalism, globalism, the war on drugs, NAFTA, *maquiladoras*, Homeland Security, border walls, Minutemen, "illegal" immigration, human trafficking, corporate prisons, greed, racism, and the growing trend to hate someone just because he or she is different from you—all contribute to the negative image of the border today. I find it difficult to imagine a border with harsher contrasts than the one that separates the United States and México. *Tan cerca a los Estados Unidos, tan lejos de Dios*: the folk wisdom of *dichos* like this one rings true when we think about the clash of these two nations. *Es un choque cultural de infinitas posibilidades.*

Stuck in the middle of this culture clash is the Mexican American. *Tan cerca a los dos e igual de lejos de Dios.* Tragedy and difficult circumstances are nothing new for Mexicans and Mexican Americans. Ever since they began to settle the Southwest, even before it became part of the United States, they have withstood challenges. However, we cannot deny, nor should we, that the Spanish and later Mexicans participated in the cultural genocide of Native Americans and displaced many of them from their historical homelands. For native Hispanos, it was the culture of fencing that introduced a whole new degree of class,

race, and social apartheid. Once Texas won its independence from México in 1836, fences and the borders they symbolized created new geographic and social boundaries. The westward expansion spurred on by the Treaty of Guadalupe Hidalgo following the U.S.-Mexican War brought vast change to the Hispano way of life in the Southwest. The loss of land rights, the erosion of the Spanish language, and the creation of a second-class citizenry are the results of this war and ensuing treaty. The landscape was changed forever, and with it a familiar way of life all but vanished.

The dicho *Cuando vino el alambre, vino el hambre* is proof of how the construction of fences made perhaps the most powerful change that affected the landscape, the land, and the people who worked across the Southwest United States. Before the use of widespread fencing, land was open and available for communal purposes, such as grazing and farming. Fencing prevented people from feeding their livestock on the open land, growing crops to the extent they previously had, gaining access to water for their ranches and farms, and securing materials for building their houses and firewood for heating their homes.

This forced those who lived off the land—the majority of the population at that time—to seek a livelihood elsewhere. Some were coerced into selling their land or lost it through dubious legal transactions. Many of them sought employment at their former ranches, now under new Anglo owners, while others abandoned that lifestyle and began to work in industries such as railroad and mining. But change did not come easily or without hardships. For when the fences came, hunger came.

Now fences scar the landscape across the Southwest and beyond. Their purpose today, however, is much more sinister than their designed purpose of the previous century. Fences and walls keep people out. They stand brazenly jutted against the backyards of homes, demarcate school playgrounds, draw lines across sandy beaches, and separate families and long-standing historical social ties. They create an "us" versus "them."

Border patrol agents now ride fences like cowboys did in their day. It used to be said that good fences made good neighbors. Now fences make for good politics. There's nothing neighborly about thirty-foot-high steel beams, concrete barriers, hundreds of cameras tracking our daily comings and goings, and thousands of border patrol agents armed with M4 carbine machine guns. Nowhere else in the United States are we asked with such frequency about who we are and where we're going.

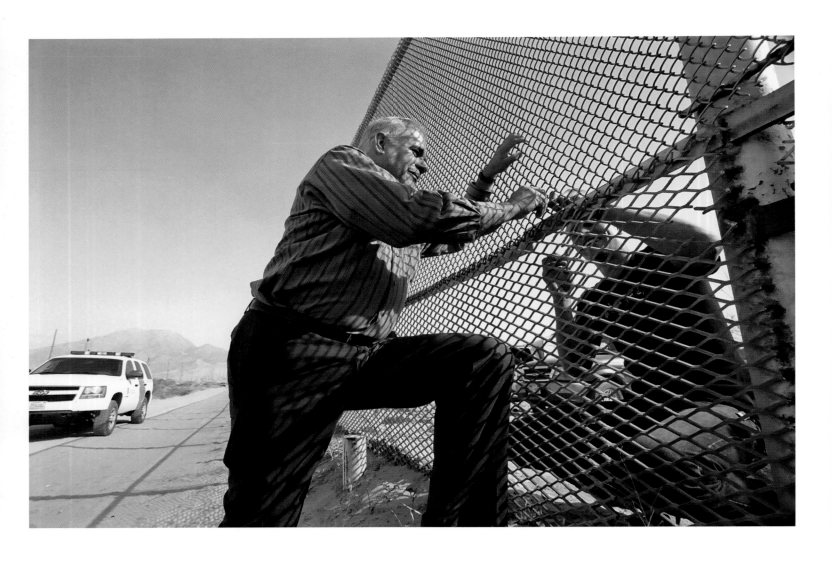

American citizens?
Yes.
Where are you headed today?

The barbed wire fence cuts me in half. I know that I am an American citizen due to circumstances that preceded my arrival into this world. The people who try to cross now are no different than my grandfather, who assumed a whole new identity when he came to the United States.

I'm going home, officer, to Santa Fe, San Antonio, Tucson, Los Angeles, Denver, Ogden, Austin, Las Vegas, Chicago, Albuquerque, Phoenix, San José, Pueblo, Houston . . . I'm going back home.

With a sly look of suspicion we are granted permission to proceed. I will cross this fence again, many more times, answering the same questions. My response never changes. Home remains the same as before. And yet these fences keep expanding and rising. I slowly accelerate into the desert, look out to the far distance, and wonder how beautiful everything must have been before the fences came.

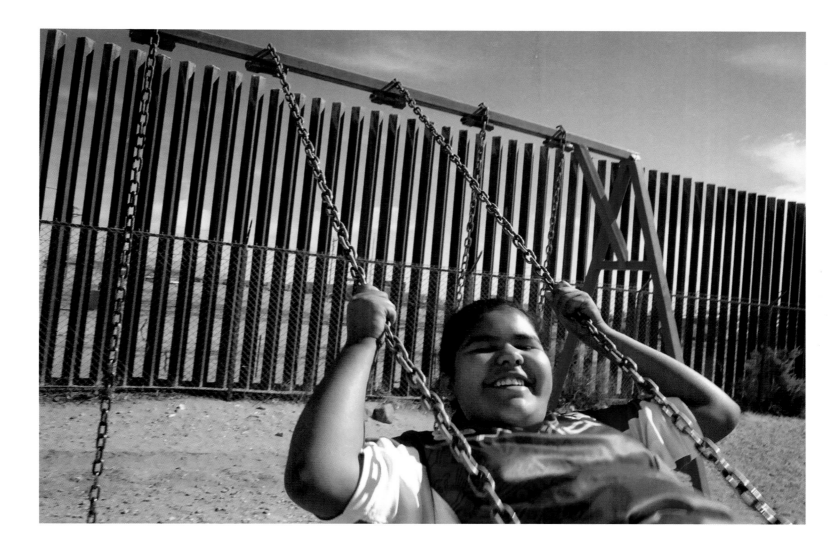

It was difficult to tell if the buildings were half-built or half-destroyed. It is common for Mexicans to construct their homes in phases. They purchase cement in bags so they can erect one wall at a time. Rebar juts out the tops of unfinished roofs, exposed to the air. Houses remain unfinished until the money comes in. But Mexicans are patient. Their use of language expresses a sense of time that defies the precision of minutes and seconds. It is no wonder that the verb *esperar* means both "to wait" and "to hope." Similar to the word *ahorita*, which possesses a powerful, yet quiet, verblike nature, it softly commands us to wait until the unforeseen future. It's almost as uncertain as the subjunctive. Time—there is no better cultural metaphor to explain the essence of the Mexican people: the inability or unwillingness to live beyond the present, yielding to God's providence for even the most mundane daily ritual of waking up. Under this famously Mexican mentality, long-term planning is hard to come by. *Porque mañana, pues, si Dios quiere.*

The Mexican outlook has been bleak for some time. For México, hope for a better tomorrow is trumped by today's grim reality. *Los gritos de "¡Que viva!"* represent more than

ever a plea that often receives no echo. And I'm not just referring to actual lives, but everyday culture. Cultural *convivencia* is suffering daily casualties. No statement could be more fitting than this for the space along the border between México and the United States. This much was clear during a visit to the Cinco de Mayo celebration at Ignacio Zaragoza Elementary School in Palomas, Chihuahua. I don't recall hearing any gritos of pride and patriotism that day. Death had been summoned.

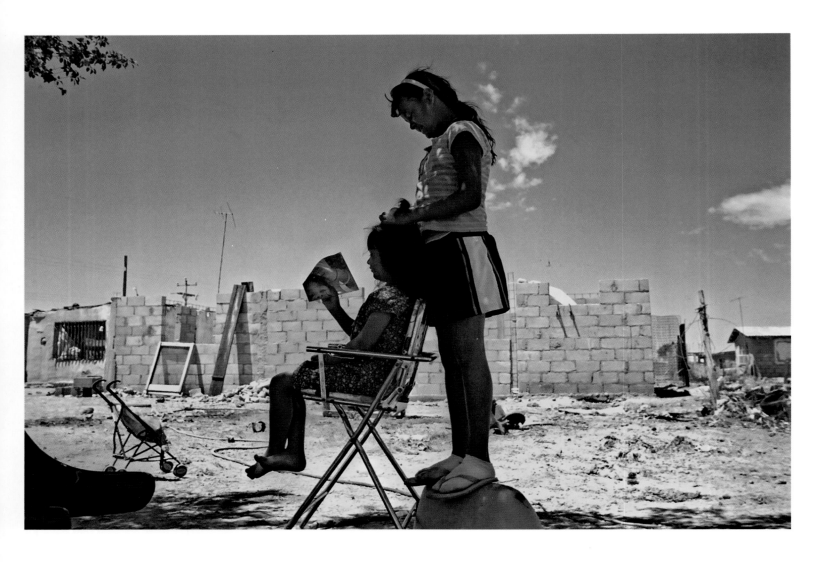

When I first saw the harsh living conditions in Palomas, it was easy to think that life here was over and that its sad, present state had been depleted of any hope for a better future. Scores of people and jobs had left. A trio of young men who traveled from Aguascalientes was daunted by the newly constructed border fence. Their unfocused eyes, hunched shoulders, and somber demeanor made their plans for Denver seem like a fairy tale. Beggars and merchants crowded the main street near the border crossing, trying to sell last-minute memories of México. Senior citizen tourists waved off the candied peanuts and Chiclets, mouthing, "*No, gracias*" through veneers and bridge work done by cheap Mexican dentists. Mangy dogs emerged from their cemetery night watch and roamed the streets in packs just like the narcos had the night before. Desperation tainted the air.

As we drove through the town's backstreets, the helpless scene replayed itself block after block. Then something caught our attention out of the corners of our eyes. Amid the broken-down houses and littered yards were two girls playing in front of a dilapidated cinder block structure. They acted as any

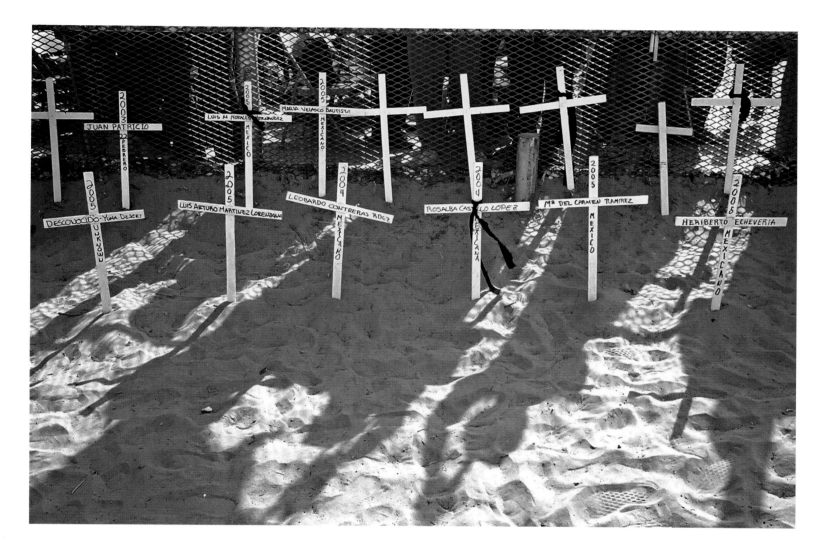

other young girls would, living in their own imagined states of existence, naively unaware of the fractured world around them. As the younger girl sat in a discarded high chair and peered at us through a broken mirror, the older one stood over her and combed her hair. The scene was powerful. Here were two young girls whose play represented an innocence that defied the current plagues of this small Mexican town. The moment was proof that a piece of tomorrow was still intact.

Unfortunately, girls and young women are often the targets of crime in México as they are routinely kidnapped, raped, and murdered and their bodies mutilated, particularly in the state of Chihuahua. As a result, parents and community members have learned to become extravigilant. Children are especially at risk in poorer communities, where these dangers are all too real. We were reminded of this dreadful reality when the parents of those two girls arrived home. As we slowly drove away, we exchanged awkward hellos through rolled-down windows. Although we meant no harm, three men in a car is cause for suspicion in northern México. It should have been no surprise when the local police arrived and demanded an explanation.

We nervously pondered our fates as we made our way to the police headquarters. The parents were legitimately concerned. They wanted to know who we were and what we were doing. More precisely, they wanted to know who the American man with white hair was and why was he taking pictures of their daughters. After a lengthy and delicate conversation, we finally set everyone at ease.

In spite of our brief, albeit uneasy, encounter with the law, the experience had been worth it. For here in this struggling community, despite the poverty and violence, it was refreshing to see that two young girls could still play as children and that their parents still dreamed of a better tomorrow. Life would continue. So on this Cinco de Mayo, in the face of desperation, the people of Palomas celebrated what little they could. One day, in some unspecified time in the future, the people can return and finish building what they started.

In México, patience is not a virtue, it's a must. *Ahorita* does not mean "soon"; it means you wait in silence until you've almost given up hope.

¡Que viva México! . . . ¡Que viva!

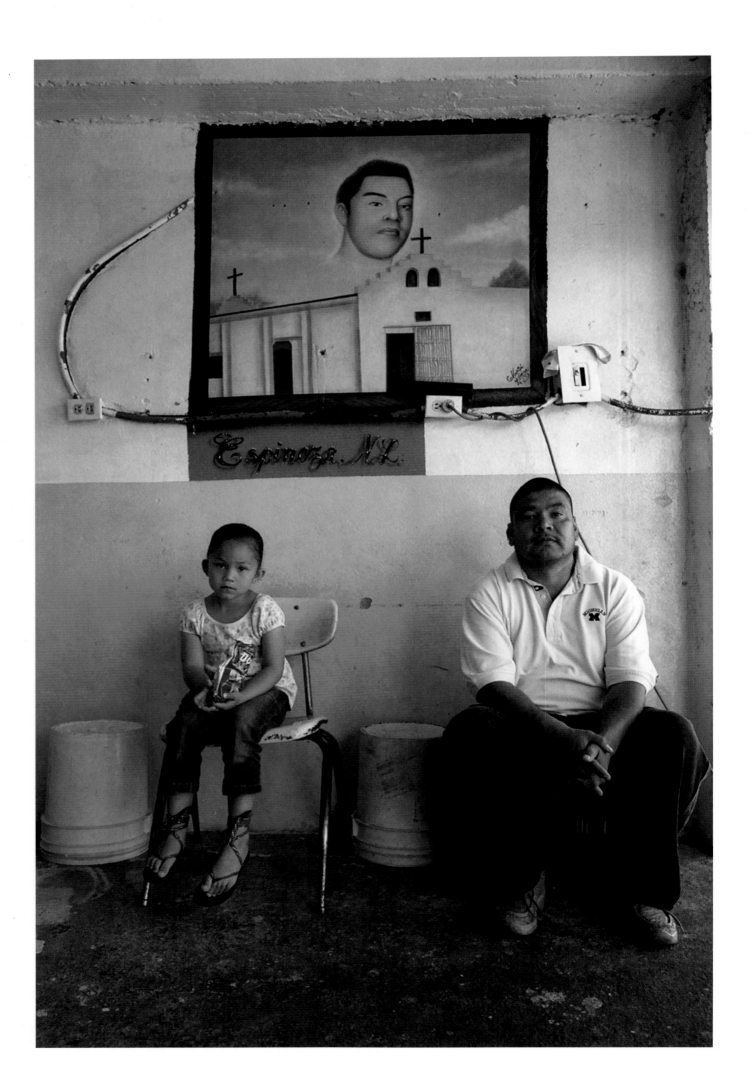

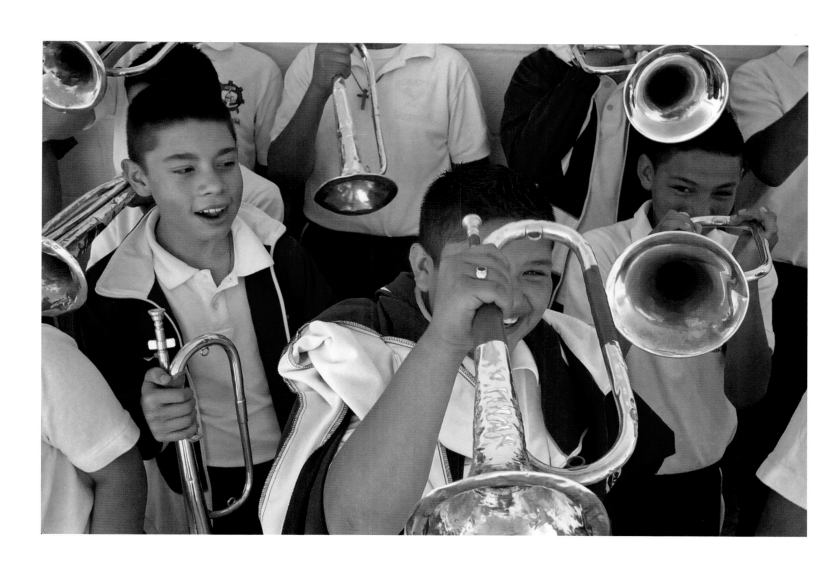

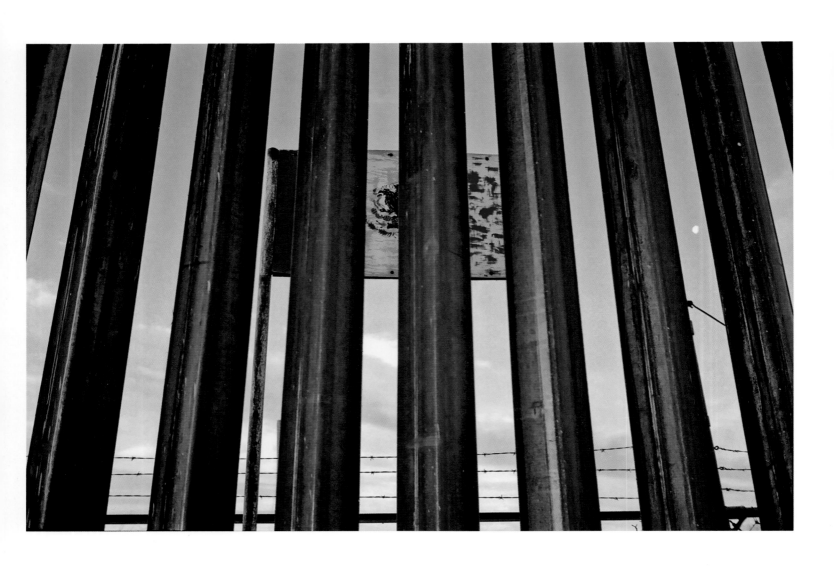

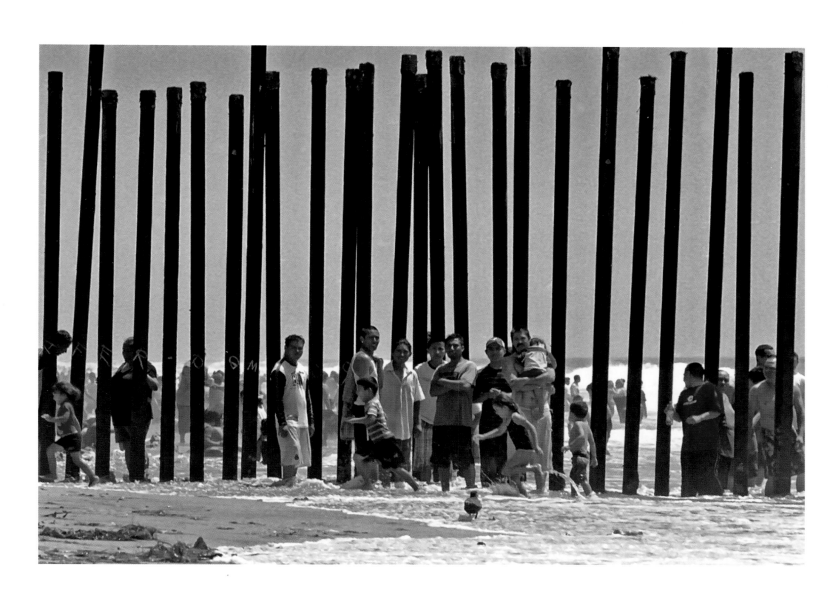

En este país y en el mío

> ¿ay amigo, a qué tiempos llegaremos
> en este país y en el mío?

mi patria querida
te echaré menos cuando esté lejos de ti

aunque te conozco hace nomás unos cuantos días
ya pudiera quedarme aquí
en este lugar de antigüedad
moderno y mesteño
envuelto como si en una sábana
de colores que fueron brillantes
y que ahora muestran nomás el recuerdo
de un rico antepasado

un pasado como páso de viejez
pasando rápidamente
al futuro que no sigue adelante
pero para 'tras

> ¿ay amigo, a qué tiempos llegaremos
> en este país y en el mío?

aquí también lo ajeno volviéndose nuestro
y lo nuestro cosa ajena

¿qué tal se mirarían tus montañas
bajo cielos claros?
montañas que ahora son sombras
en el horizonte

todo se aparece así
visiones y ilusiones tapando el sol
que no se asoma por causa
de la nube industrial

y siempre el hombre trabajador
saz y saz y adelante
adelante y agachado

> ¿ay amigo, a que tiempos llegaremos
> en este país y en el mío?

vuelan las banderas
rotas y sucias
con el eco de un grito de ayer

no son las riquezas materiales
que nos van a librar
de estos grillos y cadenas
cadenas relumbrando como si fueran
oro en la distancia

fuimos equivocados ayer como hoy
largo ha sido el camino desde entonces
hasta el presente

> ¿ay amigo, a qué tiempos llegaremos
> en este país y en el mío?

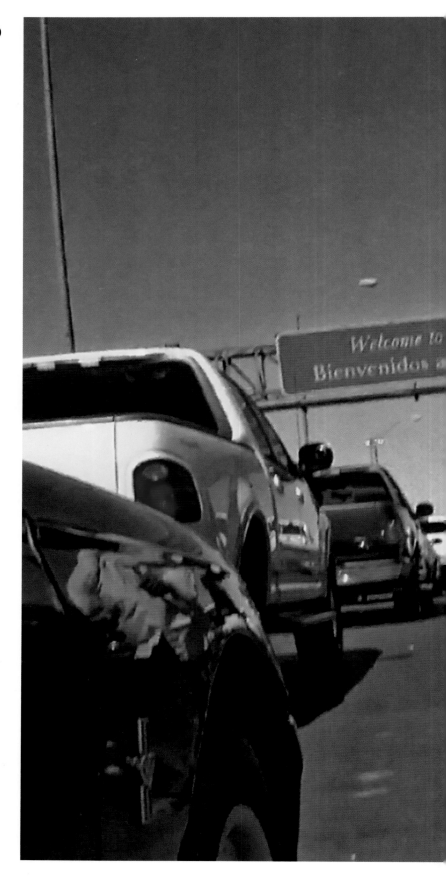

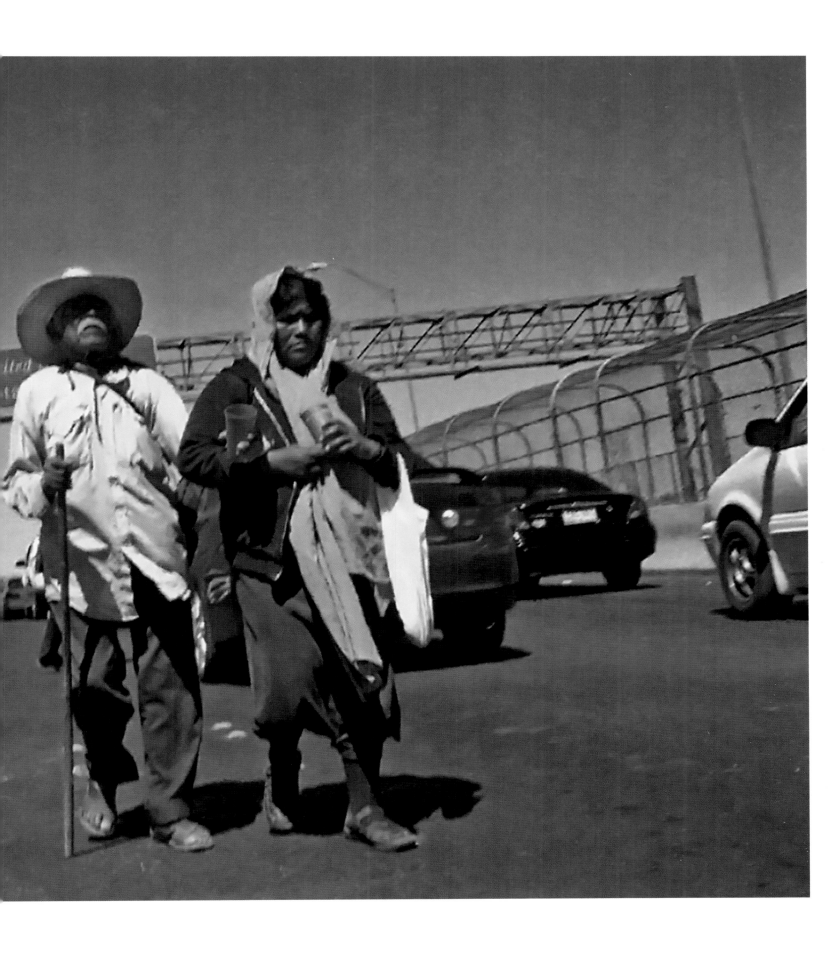

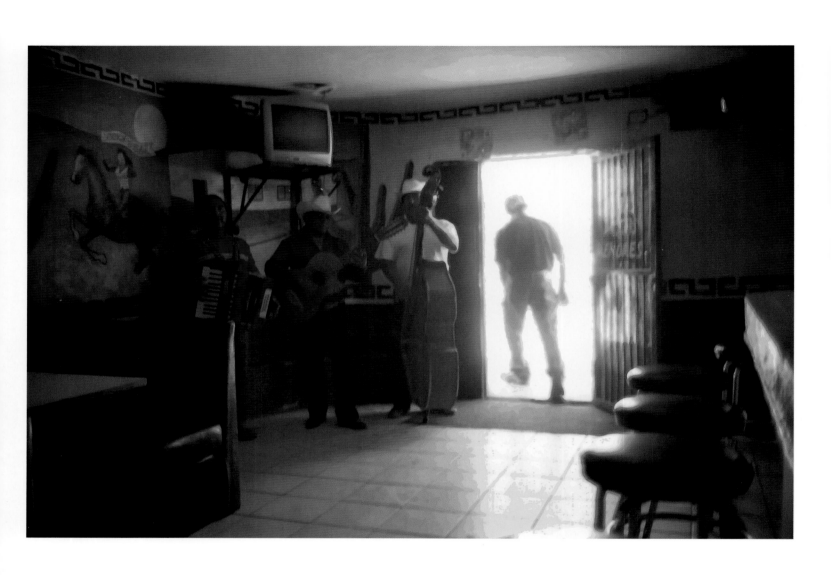

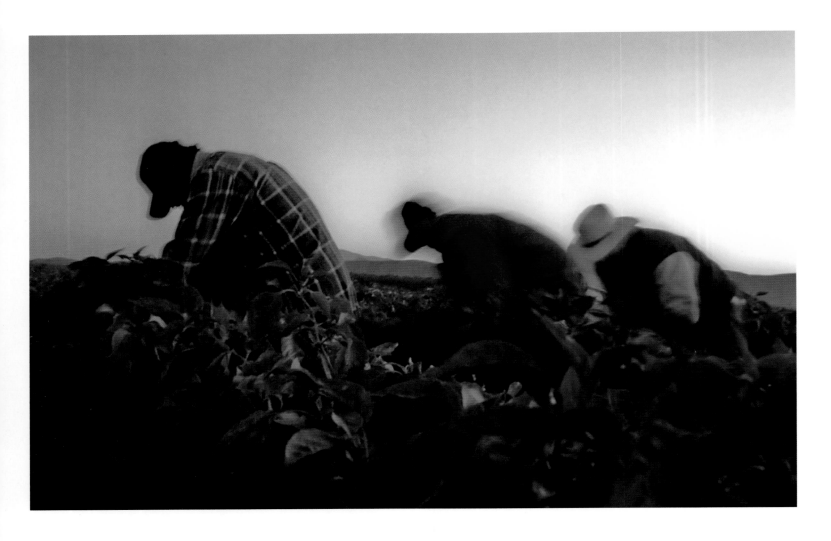

There's nothing more beautiful than watching the sunlight creep over the mountains as a new day begins. You just want to sit and take in the spectacle and remind yourself of the awesome splendor behind nature's daily blessings. That is what I feel when I see such a sight in the southern New Mexico desert. But with the sun come the heat and the day's work. This is what I witnessed on a blistering summer day in Garfield, New Mexico, during the height of the green chile harvest.

We arrived around 9 a.m. and began to scout the local farms for a sign of life. It did not take us long to find a field dotted with workers wading through waist-high green chile plants, moving at a steady pace. The group of about thirty field-workers consisted mostly of middle-aged men and a few younger women. The men resembled what they always look like in my imagination and in real life. They are strong, with dark, almost leatherlike skin, hardened through the years of manual labor in full sun. Their features speak of ancient bloodlines. The wrinkles that crack their faces are like riverbeds of memories that have shed tears, laughed, and endured one too many hardships. Although Mexican, they are just one or two cultural conquests away from being full-blooded Yaqui, Tarahumara, Apache, or Piro-Manso-Tiwa Indians. They may not remember, but their faces tell the story.

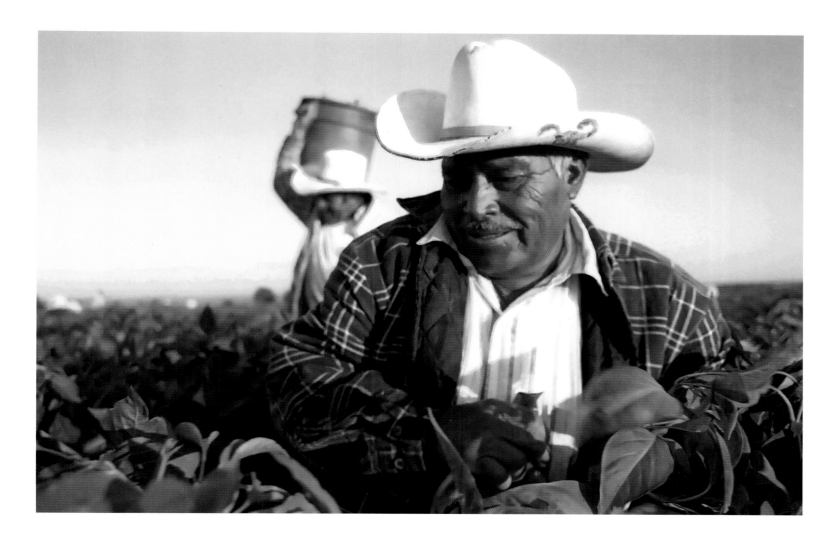

The heat is almost bearable, but the altitude intensifies the burning effects of the sun on the skin. The men may not have any formal education beyond a few grades, but they have knowledge and wisdom. Contrary to the common sense of nonworkers, the field laborers cover themselves from head to toe. They wrap their shoes in plastic supermarket fruit bags to protect their feet from the muddy fields and moisture. They wear long-sleeved shirts to protect their skin from the sun and keep their bodies cool with sweat to prevent heat stroke. And they all wear hats, mostly broad-rimmed ones, to protect their heads and provide a little shade from the punishing sun.

They understand how to work with their bodies and not overexert themselves. They move fluidly, with precision. They know exactly where to snap off the green chile with ease, to protect the plant. They work together and yet keep to their own areas in order to maximize their yield. They work hard and steadily, filling up their five-gallon buckets to the rim, dumping the contents of each into the back of a truck in exchange for a *ficha*, one poker chip, worth eighty cents. By the day's end, the most productive and physically able workers can collect up to seventy buckets, or fifty-six dollars for a day's work. But most of the group, particularly the older men and women, collect much less.

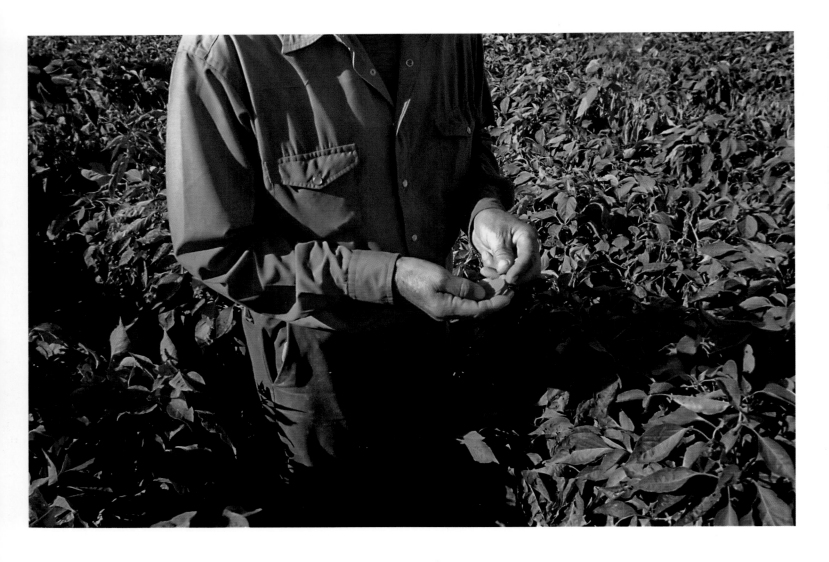

These men and women are not nameless or faceless. They each have a story worthy of being told and recorded. Alfredo, a disabled Chicano Vietnam veteran, tells me he was recently released from prison after serving ten years for stabbing five people in retaliation for beating him with a crowbar. A middle-aged foreman, Manuel, who directs the workers to keep up a brisk pace, offers me half of his lunch when he sees I have brought nothing to eat. Maribel, his young daughter, works by his side. A man who looks to be more than eighty years old—but is in his early sixties—says proudly that his mother was Yaqui. His body hunches over, and he can barely walk after a lifetime of picking lettuce and other root crops. Without the help of someone to give him a boost, he is physically unable to step onto the trailer that carries the portable toilet. His body is now nearly unable to perform manual labor, but it is all he knows.

Garfield is a small town, and there are more than a dozen fields of green chile between there and Hatch, the green chile capital of the world. I know that all of these men and women could not be from this area. Then I notice the

yellow school buses parked down the road underneath the shade of a few trees.

> *"¿De dónde son ustedes?"* I ask, thinking they're from a nearby town.
> *"Somos de Juárez,"* they tell me.
> *"¿De Juárez?"* I reply with surprise. *"Pero Juárez es más de dos horas de aquí. ¿Entonces a qué hora salen de Juárez, como a las cinco?"* I ask them naively.

The story of how we get our food from field to table is a sad truth that most people choose to ignore. Anti-immigrant activists claim that "illegal" immigrants take away jobs from hardworking Americans. The owner of the farm tells me that he would hire Americans if they wanted to pick green chile for the going rate, but he finds few takers. So he must rely on these men and women, most of whom come from Juárez and the small towns in northern Chihuahua, to pick his crops. The men continue to tell me that they cross the international

bridge from Juárez to El Paso around 2 a.m. every morning. In downtown El Paso there will be several yellow school buses waiting to take them to their destinations—Garfield, Hatch, Deming, Anthony—all to pick green chile and other seasonal crops. It is a harsh reality that is difficult to imagine for those of us who live to work, but not for these men and women who work to live.

A week later we arrived in downtown El Paso at 2 a.m. As we drove through the quiet streets, making our way toward the international bridge, we began to see signs of life. At the historic El Paso Street near the bridge, a handful of yellow school buses lined the curb, all waiting for their passengers. Many men were already there, standing outside with their coffee, exchanging polite handshakes and *buenos días*. Others were already on the buses, resting up for a hard day's work. Little by little, more men arrived and boarded the buses. Almost all of them were middle-aged or older. They were men who had labored their entire lives, and their faces and body language showed it.

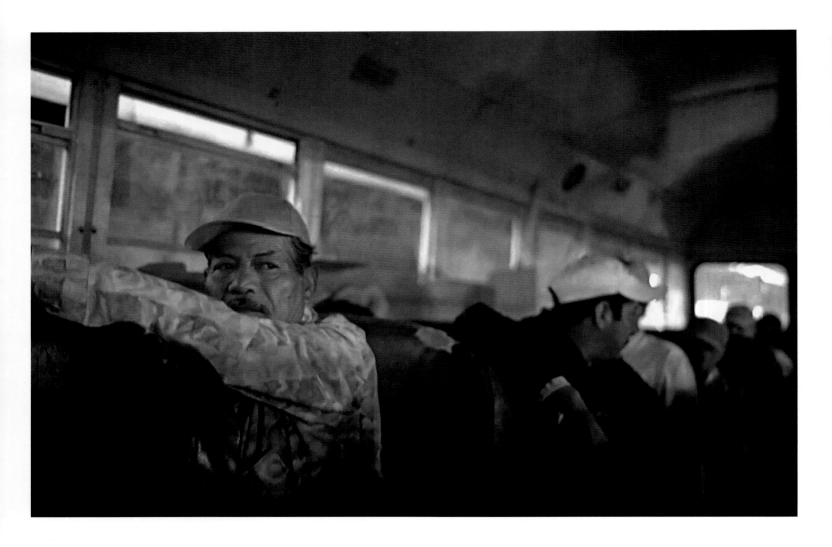

On yellow school buses they head north to work for our benefit. They are not undocumented, and they are certainly not "illegal" or "alien." In fact, many of them are legal residents of the United States, but prefer to live in México, their home. Yet they play by the rules and do so without complaint. They must pass through two immigration checkpoints so they can work for us, pay our taxes, and help support our local economy. In return, they receive the opportunity to pick seasonal crops for low wages.

They arrive in Garfield before dawn. It is still too dark to see in front of you. They sleep on the bus and rest as much as they can for a bit longer. Then, while it is still dark outside, they begin to shuffle off the bus. They are handed their buckets, and with the bus's headlights beaming through the rows of green chile, they slowly disappear into the darkness and

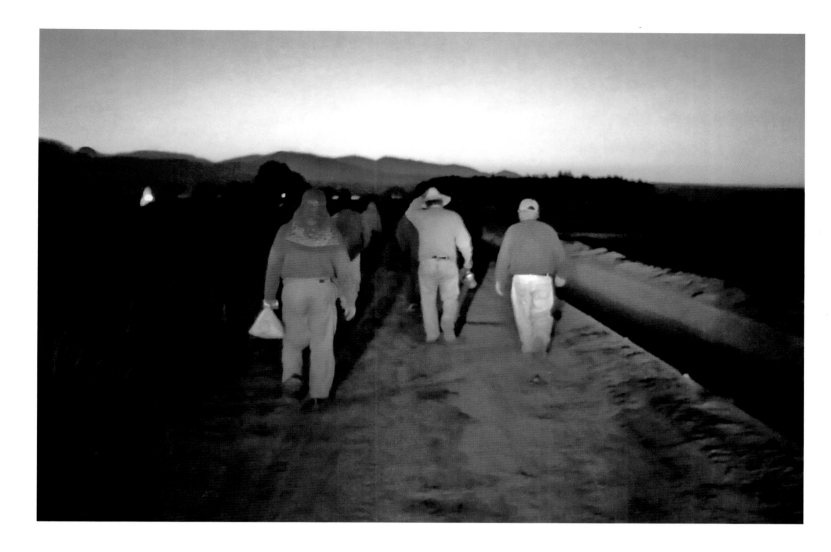

begin picking. Soon a glimmer of light begins to peer over the mountaintops. It is a beautiful sight to see. For a moment, I am caught up in the natural wonder of the southern New Mexico high desert. Then I hear the people at work. To my surprise, they seem glad. A few whistle, some older men sing, others tell jokes and poke fun at one another. They are a community.

Before long the sun would rise and the light of day would peak over the mountains. We would go home, and they would begin the trek back to Juárez that afternoon and start the whole process all over again after midnight. For most of us, these men and women are invisible. Some choose to ignore their existence altogether. But they are human beings with faces, names, and stories who deserve more than a bus ride home. They deserve dignity.

Soy una persona que doy consejo, y como yo digo así es. Los consejos que yo doy, así son. Y nunca he fallado. Mis hijos son iguales, vienen y me preguntan, "Mamá, ¿cómo ves, cómo saldré aquí?" Entonces yo me le quedo mirando. Le digo, "Vas a salir bien, vas bien. Mal no vas, vas bien."

—Simona Galaviz Murphy

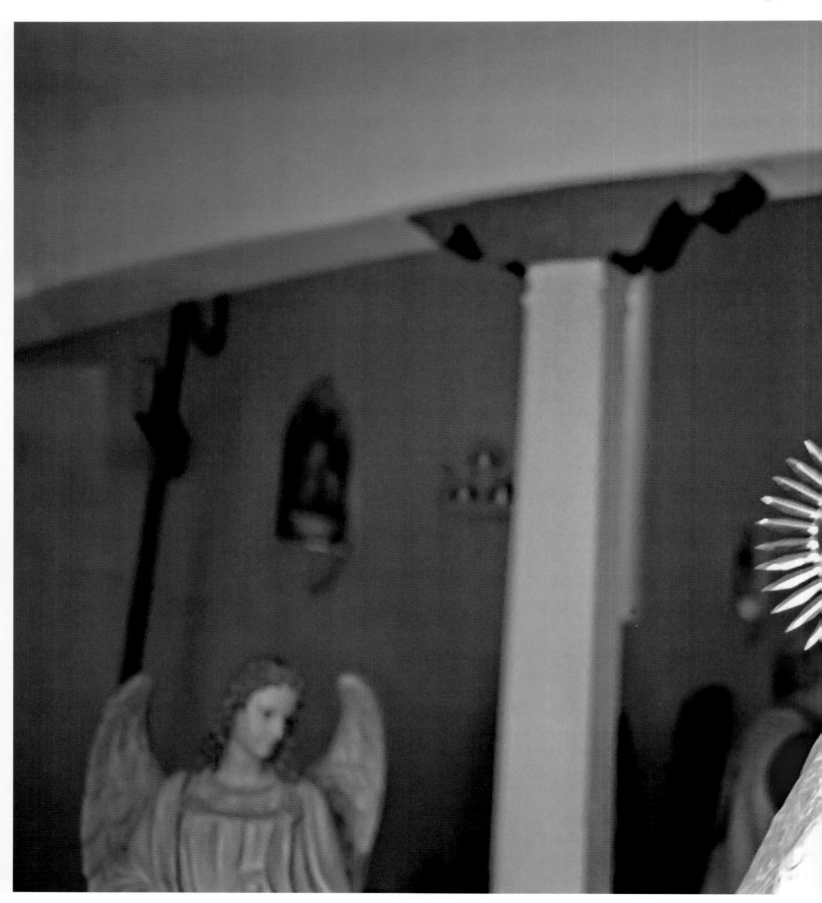

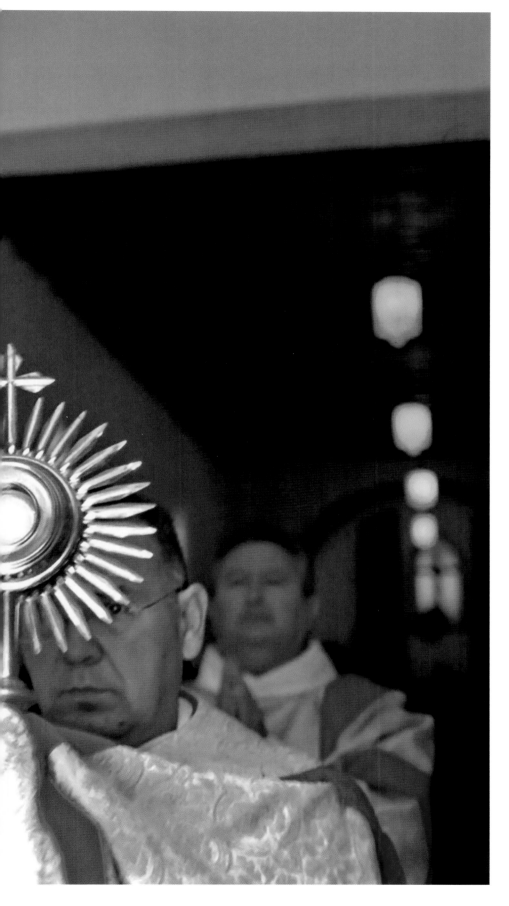

Si Dios Quiere

A few years after my parents divorced, my father began to take my brother and me to Catholic Mass. My mother was Baptist, so we grew up without any formal understanding of the Catholic faith. We never went to a catechism class or even a church bazaar. But one Sunday morning my father took us to Saint Patrick's 10:30 Mass.

I was amazed at the order of Mass and how the parishioners worshiped in unison and actively participated. Standing up, sitting down, kneeling, getting up, making the sign of the cross, standing in line for Communion, kneeling again. Mass had a rhythm that Baptist sermons did not. Everybody played their role in the orchestrated celebration. Unfortunately, as a newcomer to the Catholic faith, I was the note that disharmonized the service. Without any formal indoctrination into the Roman Catholic Church, I was to be baptized by fire. Although I wanted to belong, I struggled with each movement, gesture, and song. I finally felt comfortable toward the end of Mass, for at least I knew the Lord's Prayer. Father DeGeorge then extended us a sign of peace and asked us to offer each other a sign of peace. A first-time Catholic, I did not understand the ritual and did not clearly hear the refrain "Peace be with you." As I saw people hugging and warmly exchanging handshakes, I turned to the woman next to me, shook her hand, and said, "Pleased to meet you." It sounded close enough, but her odd look told me that I didn't perform the ritual quite right.

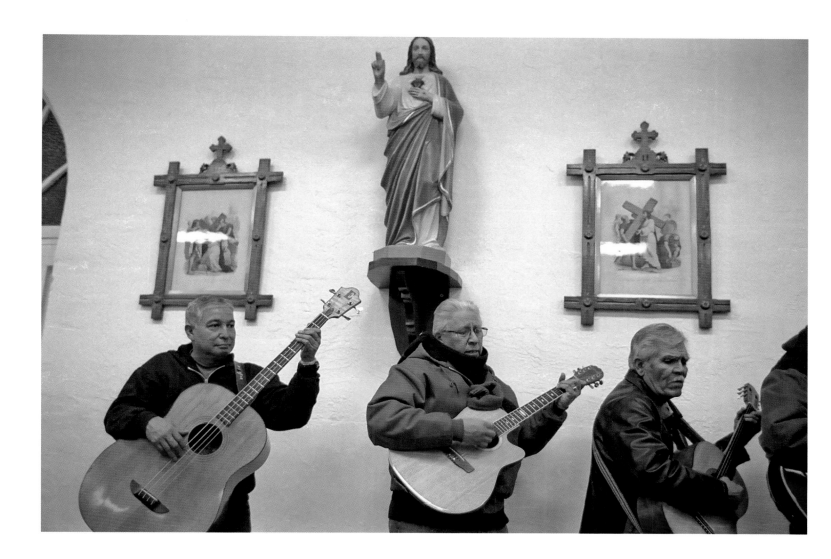

At that time the Southern Baptist Church (at least mine) had one message: get saved or go to hell. You went in dragging your feet and left feeling like you had done your duty. But Catholic Mass was about community, and that's what Saint Patrick's was for me. The parish was located in Lindale Park in the north side of Houston, near the house where my father was born. At Mass we would frequently see his friends from the neighborhood: Juan the mechanic; Mundo, who hitched rides since he did not drive; and old flames from his glory years. After Mass we ate tacos *de chorizo con huevo* or menudo in the parish hall, prepared by Las Guadalupanas. Sharing gossip between tacos and testimonies was memorable. We would sit and eat and enjoy each other's company as a trio of older Mexican men would tune their guitars and softly sing a few lyrics in preparation for the Spanish Mass. Nowhere else did blessings and chisme mix so seamlessly.

Saint Patrick's was for me one of the first sacred spaces that helped define who I am, as a man of faith and a Chicano. The sense of community was strong. When we broke bread, sang "Hosanna in the highest," and offered each other a sign of peace, we did it as brothers and sisters. We entered Mass caught up in our own thoughts; but we left together giving thanks to God, in unison. We were the body of Christ.

May the peace of the Lord be with you all.
And also with you.
Let us go and offer each other a sign of peace.

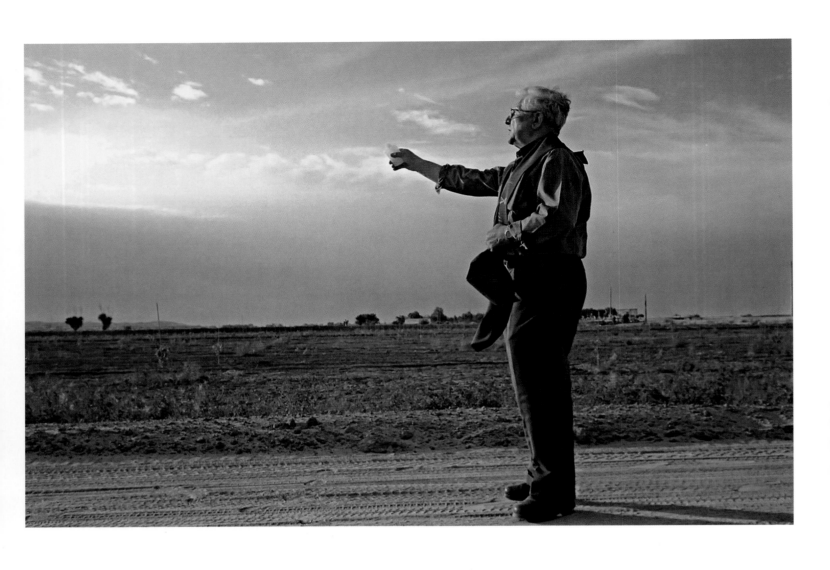

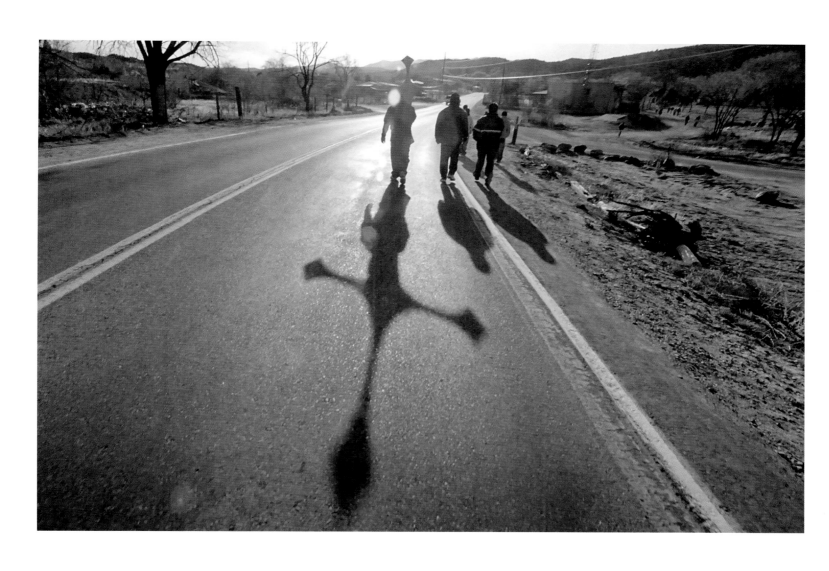

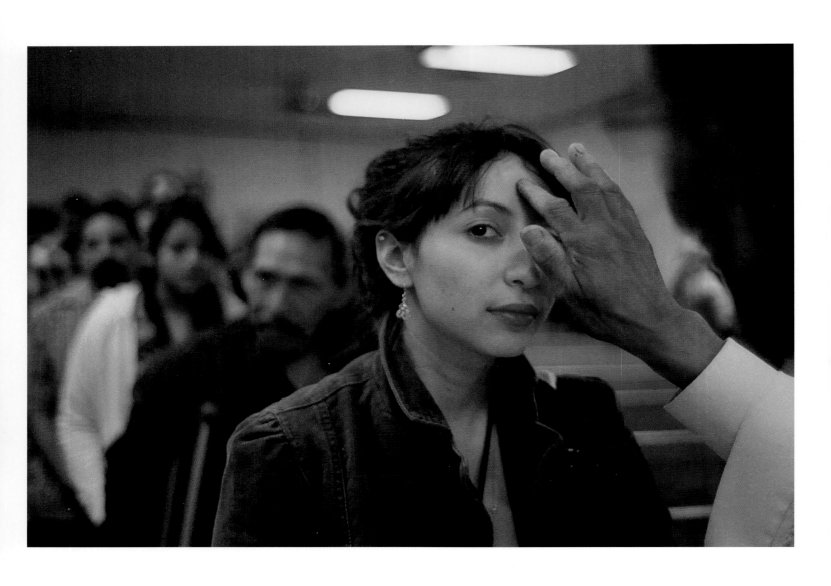

Epigraph

at the burial
three women make their way
through the *camposanto*
their gazes are set intently
on the headstones

they scan the plots
look for names of relatives
mira, mi tía Rufina

the sierras are spotted with snow
it has been a good winter in the highlands
look, el cerro de Tajique
one woman says to the others
it took our visabuelos
a week on burro to get here
her thin finger points toward
their ancestral homeland

the Río Grande flows serenely
shedding no secrets
as if belly-weaving itself through the bosque
and across los Ranchos de Atrisco

gran'ma used to say
it was from the edge of this mesa
where the Navajoses and the other Indians
that came from the west looked down
on the orchards and gardens

waited for an opportune time
to venture down and raid the fields
for fruit and vegetables

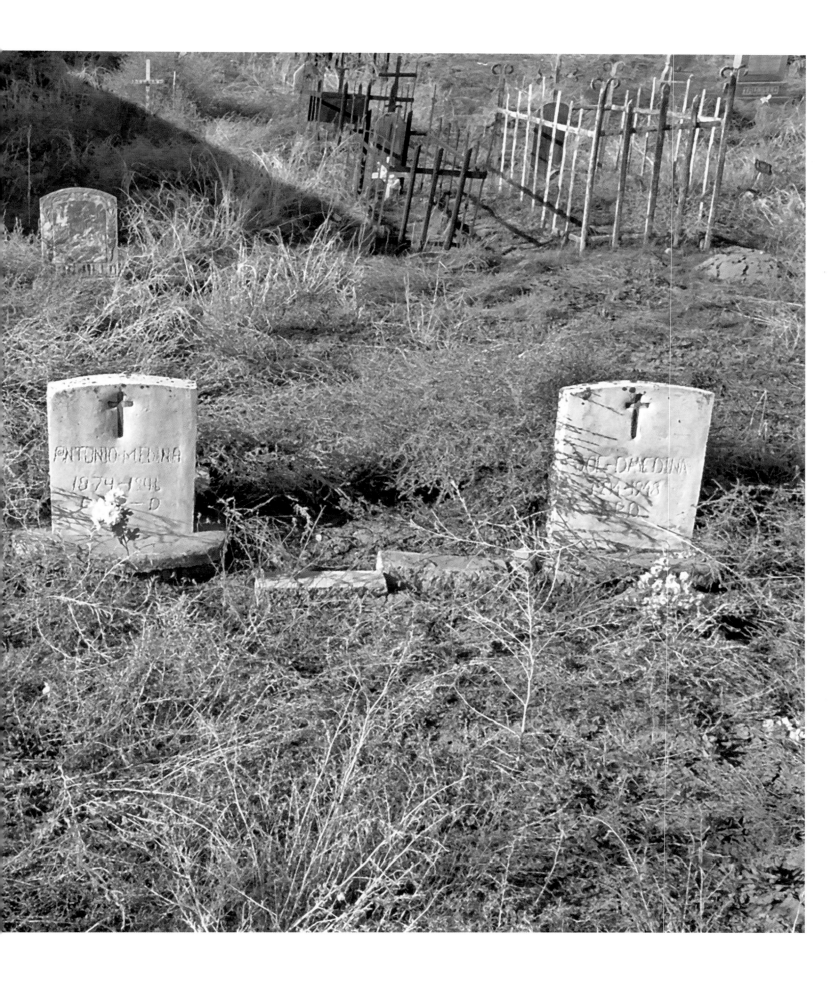

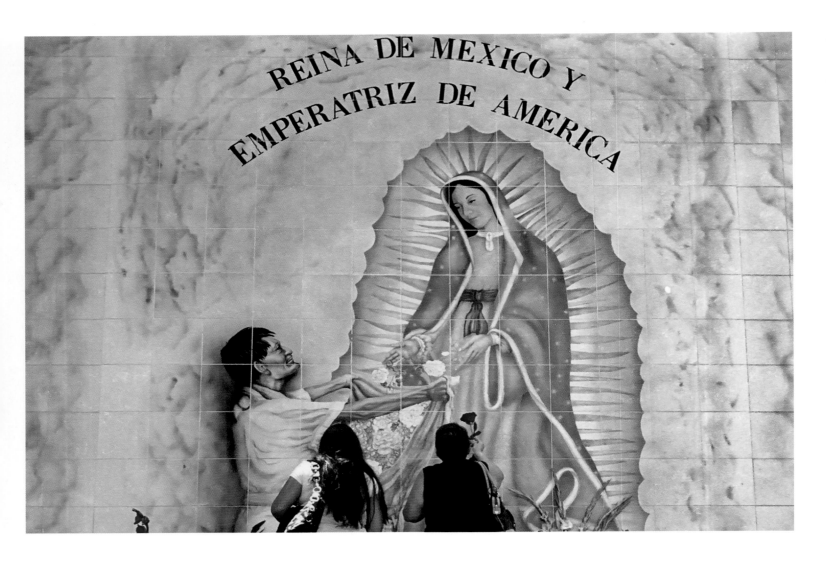

REINA DE MEXICO Y
EMPERATRIZ DE AMERICA

My paternal great-grandmother, Simona Galaviz, was born in Waelder, Texas, in 1911. She was a spiritual woman. As a child I heard stories of her curing people's illnesses. When I was old enough to understand these things better, I asked her if she was a *curandera*. She said no, but that she was a *buena samaritana*, a good Samaritan. Her memory was remarkable and her story, even more so.

In 1947 Simona was sitting down on her bed, inconsolable that her son Frank had not yet returned from the war. She rose up, went outside, and cried. She pleaded with God:

Please, Father, bring me my son back. Nothing happened
to him in that war. Bring him back to me.

Feeling helpless, she continued to cry when at that moment she heard someone tell her to get up. She went in her house, threw her arms up, and fell back on her bed. As she lay there she felt a beautiful white dove land on her chest. She knew it was the Holy Spirit. He said:

Do good with no cost advance. But do good. You'll be a
Good Samaritan, and you'll be advisor to anyone that
want your advice. But you do what I tell you. That's my
demanding to you, Simona.

The voice told her that people were going to come to her for help and for her to answer their needs. The heavy pressure lifted from her chest as the white dove took off and flew out the screen door. Simona quickly followed behind it and then watched the dove fly up into the sky until she couldn't see it anymore.

That same day a man arrived at her door seeking help for his wife, who suffered from whooping cough. From that day forward, people came from all over to consult her about their maladies. She prayed over the sick, concocted homemade *remedios*, and advised *la gente desesperada*. She did it for years and never charged "*ni un nickle a nadien.*" Instead, she taught people to thank God that He had a daughter doing His work on Earth and left them with the parting advice "Never look back, look forward." I've been doing my best to look forward ever since she recounted the story to me.

This reverence for God and faith healing was not unique to my great-grandmother. My maternal grandmother also healed by faith, but she was not a curandera or buena samaritana. She was like many other Mexican grandmothers who cared about the well-being of her children and grandchildren. As a child, when I would get sick, my mother would often call my grandmother over to our house so she could pray for me. She would take an egg and make signs of the cross over me, praying in Spanish. As I lay in bed, I would feel the coolness of the egg touching my forehead and my

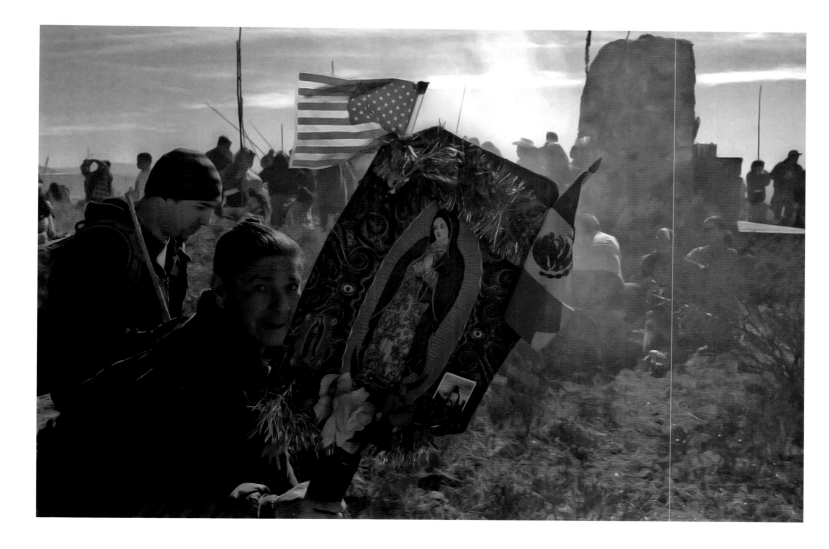

grandmother's soft hands covering me. Whispers of "*Señor todo poderoso que está en el cielo*" would cover my body as I lay still, believing in every word that I could not understand but felt with conviction. I knew I would get better soon. She would then crack the egg into a bowl and set it aside. The next day it would be discarded. By that night or the following morning, my symptoms would be gone, without fail, every single time. Even today, when I get sick, I think of how my grandma would cure me with her blessings and the egg ritual, and I begin to feel better just knowing that she still prays for me.

Religion has always been a part of my life, even though we weren't always religious. Our belief system penetrated our daily routines. It was a part of my father's Mexican Catholic upbringing or fatalistic Mexican mentality, however one may want to look at it. Nothing we did was ever of our doing; everything was granted by God. Long-term plans to buy a first home, get a job, or get married all went through God. Even the mundane was dominated by God's providence—passing an exam, getting needed overtime to pay some bills, and even waking up to a new day. Everything that we did or hoped to do depended on God's blessings and mercy. Today is a gift from God, and tomorrow, *pues, si Dios quiere.*

Though it may be God's providence that guides our lives, it is La Virgen de Guadalupe to whom many pray for guidance, protection, and help when in despair. God, for many, seems too powerful, too distant, and perhaps even too abstract. Chicanos and mexicanos need an intercessor, someone to whom they feel close, who can deliver their prayers to God. La Virgen de Guadalupe is our go-between, *nuestra intercesora.* She is the mother of México and consequently of Chicanos. Her story, whether you regard it as gospel or myth, has undeniably shaped our world.

In 1521, the Aztec empire of Tenochtitlán fell to Hernán Cortés's army of Spanish conquistadors and their Indian allies. Two years later the first Catholic missionaries began to arrive, and the cultural conquest of the Americas began. On December 9, 1531, an indigenous convert named Juan Diego, while en route to Mass, crossed the hill known as Tepeyac. This place was sacred to the Aztecs because it is where they worshiped Tonanztin, Mother Earth and Aztec goddess of corn. It was here at this spot that a beautiful, dark-skinned, indigenous-looking woman appeared and revealed herself to Juan Diego. She claimed to be the Virgin Mary, the mother of Jesus Christ. Her message to Juan Diego was simple: Tell Bishop Juan de Zumárraga to build a church in her honor on the hill of Tepeyac. The task would not prove easy.

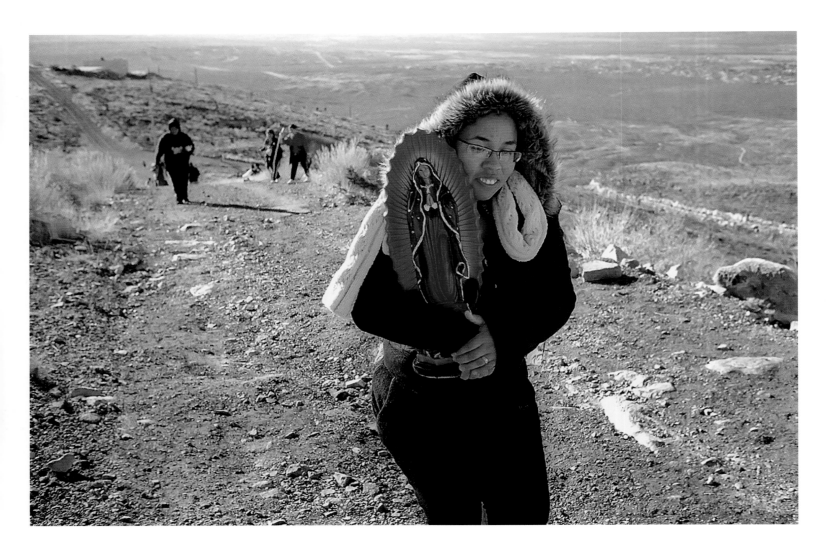

The bishop demanded proof of Juan Diego's encounter with the Virgin Mary. Out of fear and confusion, Juan Diego avoided Tepeyac for the next couple of days. Then, on December 12, while in desperate search for a priest to help his dying uncle, Juan Diego crossed Tepeyac, and again the Virgin Mary appeared to him. To fulfill the bishop's request, the Virgin Mary told Juan Diego to pick some roses from the hill and take them to the bishop as a sign.

Juan Diego gathered the beautiful roses, which were uncharacteristic for that region during the winter, in his mantle and took them to the bishop. As Juan Diego let the rose petals fall before the bishop, they miraculously left behind the image of La Virgen de Guadalupe inside his mantle. A church was soon erected in honor of La Virgen de Guadalupe, and she became the mother of México. Dark and indigenous, she was one of them. She revealed herself not only to Juan Diego, an Indian, but to the Mexican people. She chose them, and ever since they have followed her.

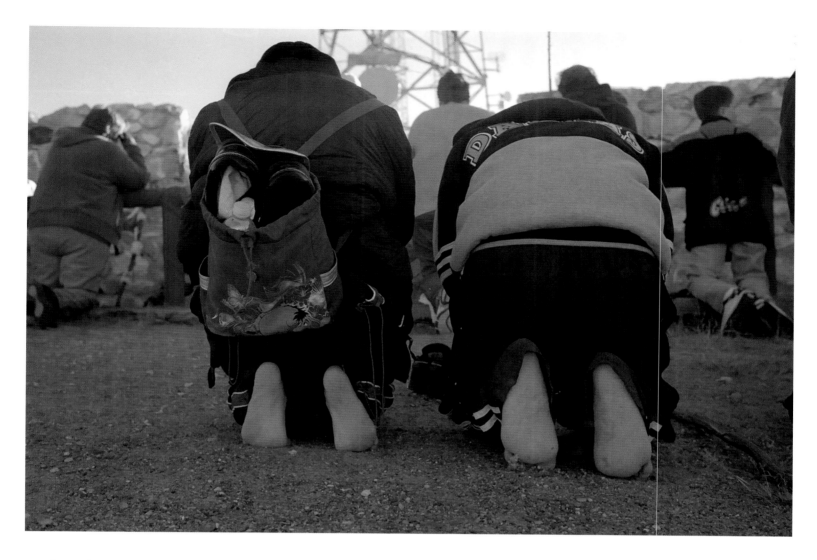

December 12 now marks the day when her followers cele-
brate her revelation to Juan Diego. Pilgrimages, shrines, and
Masses abound, all in her honor. But one does not have to wait
until this day to pay her homage. On any day, at the Basílica de
Santa María de Guadalupe in Mexico City that was built in her
honor, you can find scores of people praying to her. They go
with petitions for their loved ones who have lost their way. They
crawl on their bloodied knees, plead for intervention, and offer
her gifts of roses. They remember that she chose us; she is
Nuestra Señora.

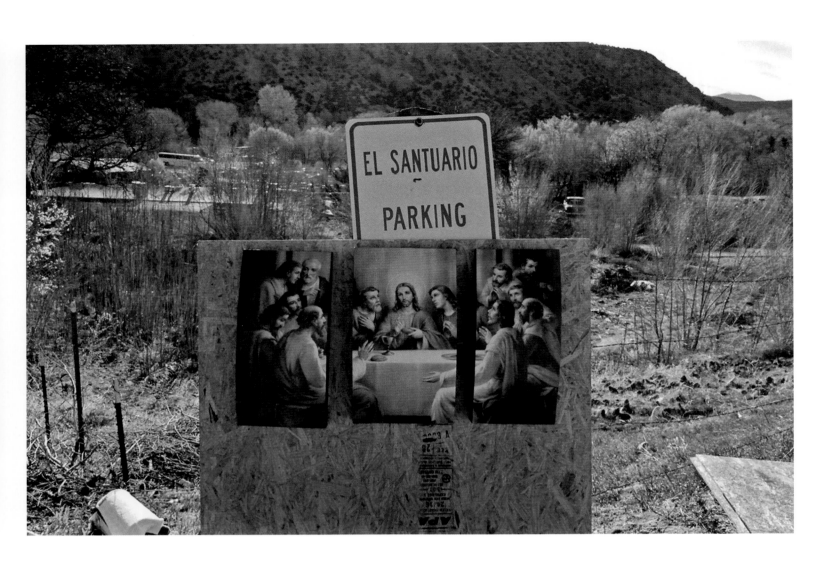

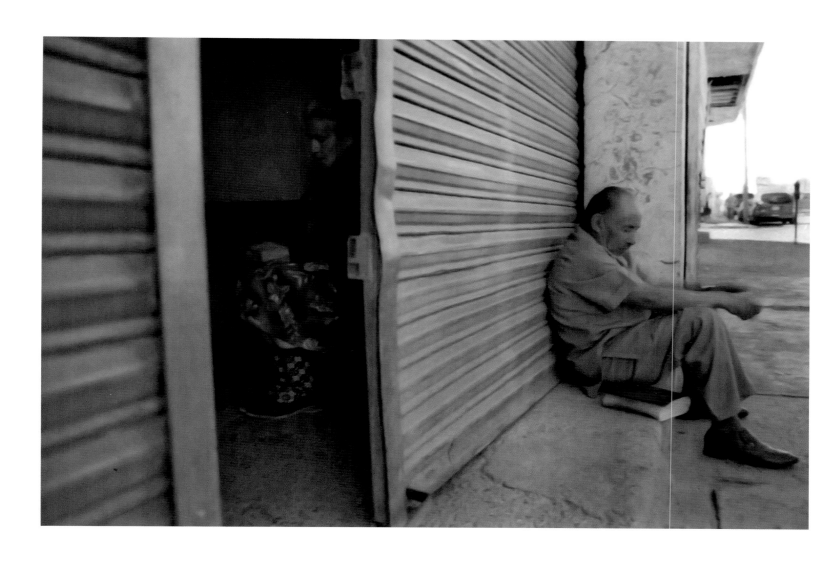

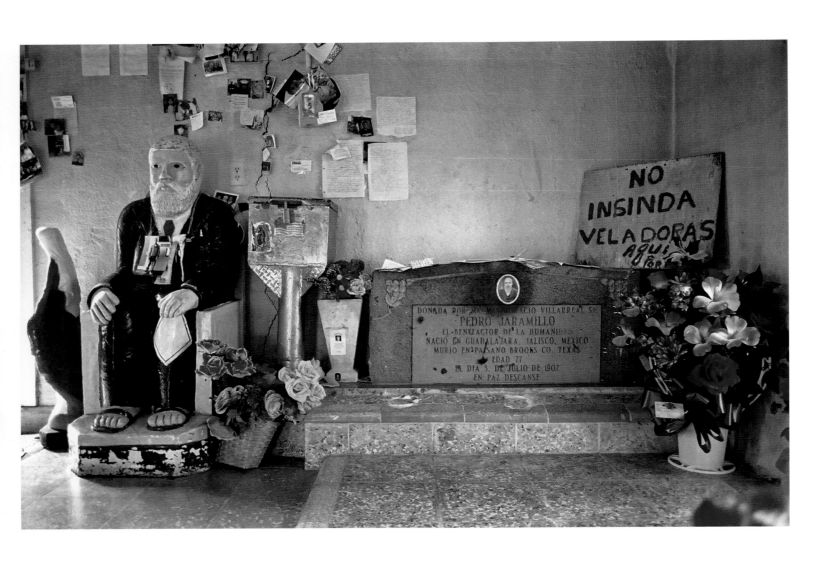

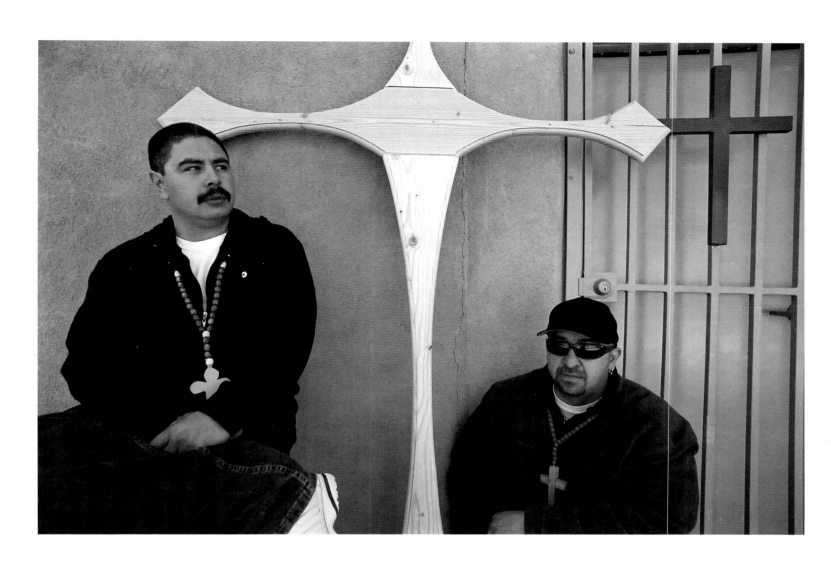

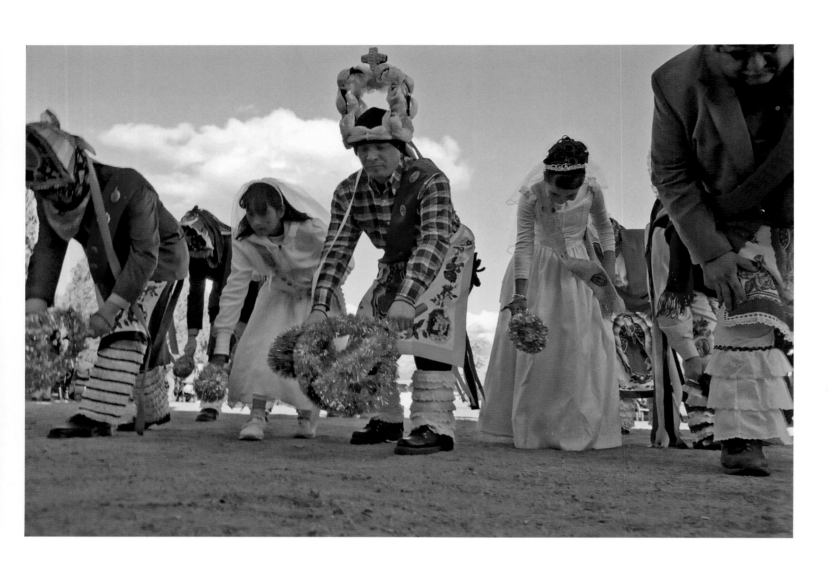

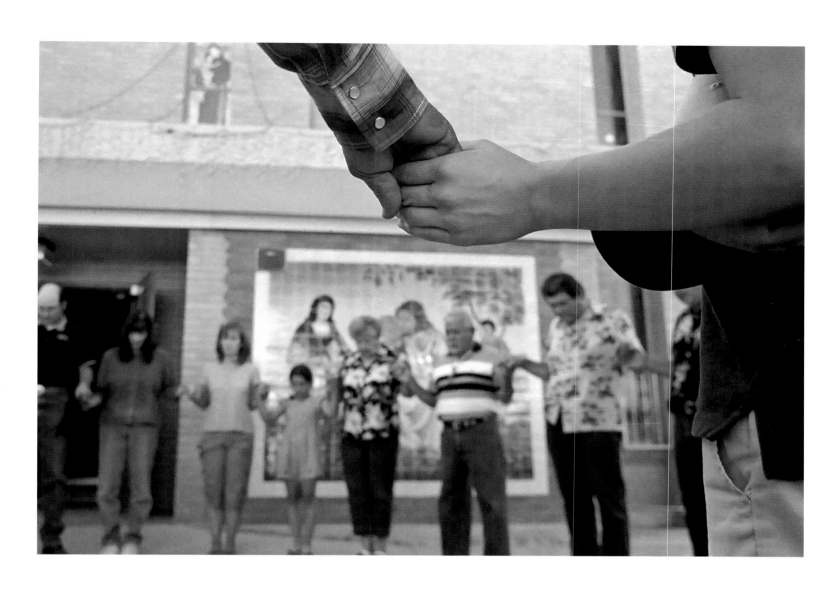

Dime con quien andas . . .

A few years ago I attended a children's book reading by a prominent Chicano author at my university. It was an academic presentation about the genre of children's bilingual literature. He read a nice bilingual and bicultural story for young readers about a grandparent figure. I asked the author how he might feel about writing a children's book based on a Chicano superhero. In my view, we already had plenty of books about *abuelitos* and magic tortillas. I felt that we needed something more profound that would allow young *chicanitos* to imagine themselves as superheroes, capable of superhuman feats and not just mundane tasks. The author disagreed with my comments. He argued that our parents and grandparents are heroes because of all the obstacles they have overcome and all the sacrifices they have made to provide us with more opportunities and better lives than they had. I understand his point, and I agree that our parents and grandparents can be our heroes and do serve as wonderful role models.

But I was thinking back to my younger days, when I would often wait for the film credits to roll to see if there were any Hispanic surnames present. Most times no names would catch my attention. Eventually, I stopped reading the credits, because I already knew that we did not play any meaningful film roles except for the typecast maid or *bandido*. But those characters did not interest me. According to Hollywood's standards, we never save the day, we do not make significant contributions to society, and, apparently, we never fall in love. In their world we barely exist. As a kid, I wanted to know that we were alive and that our lives meant something. I wanted to see Chicano heroes.

To whom does the future belong? The future belongs to those who can imagine it.

—Luis Valdez

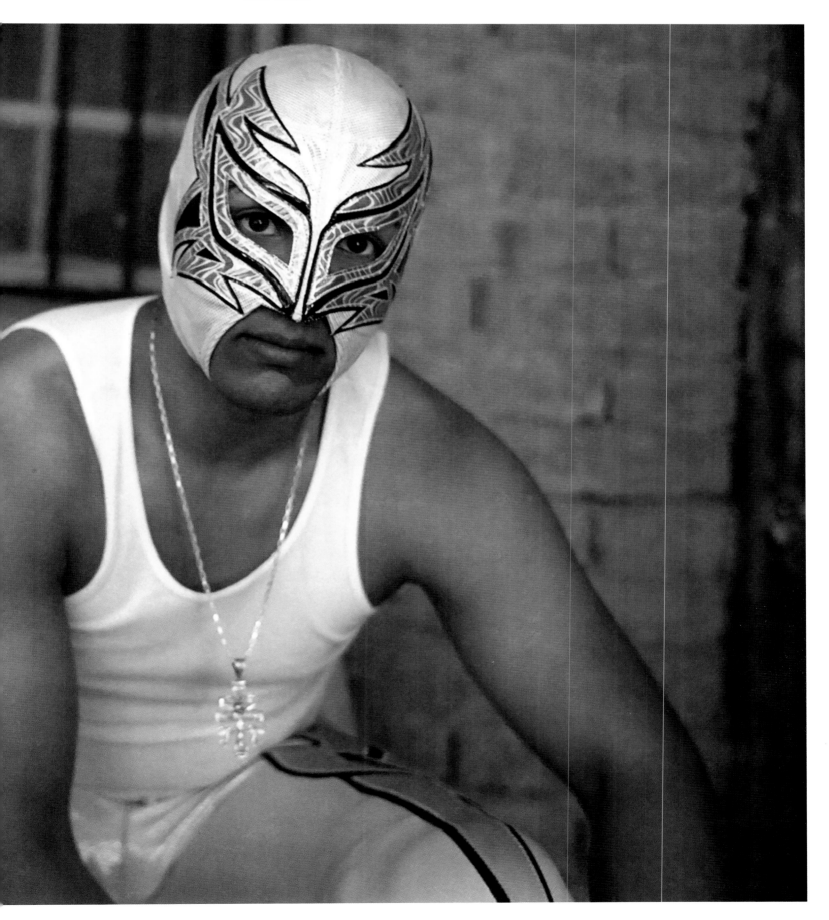

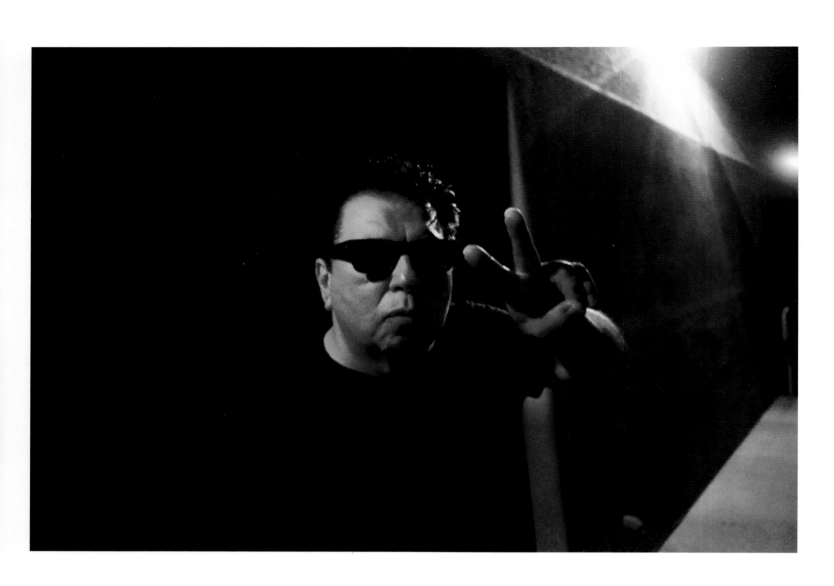

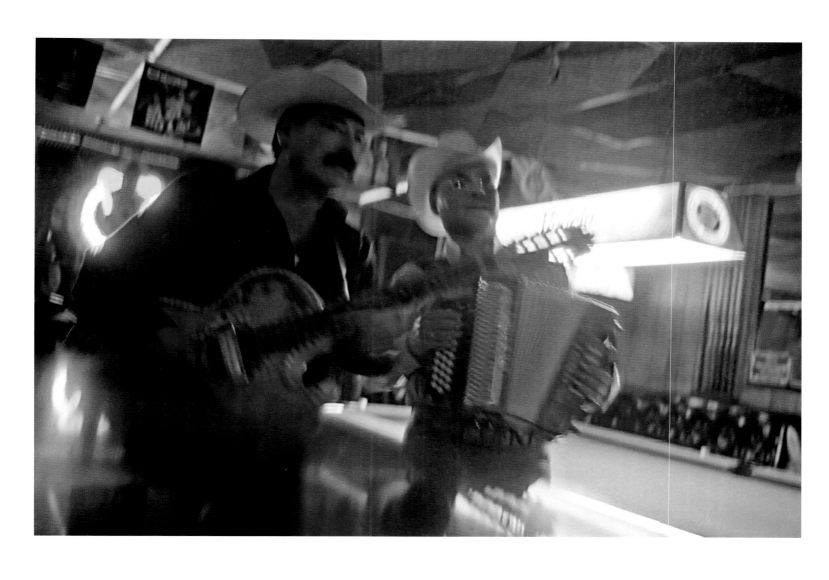

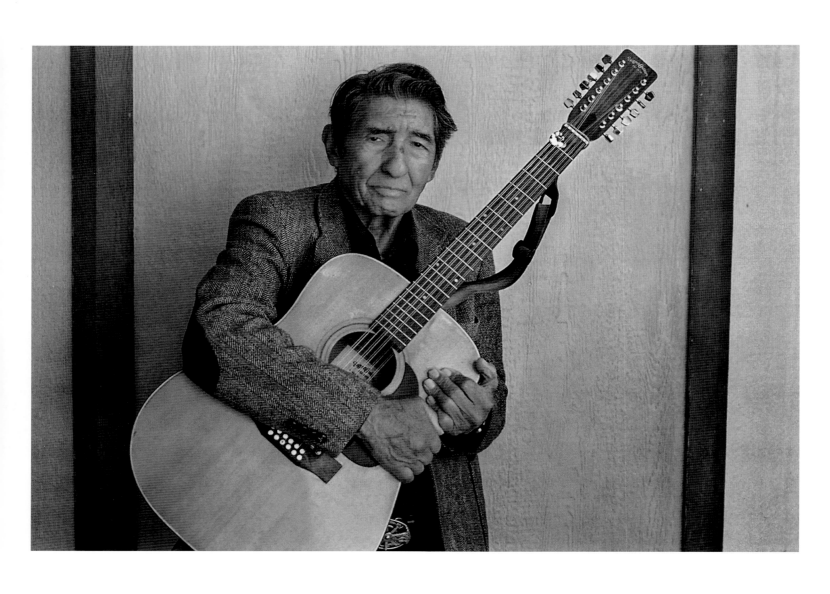

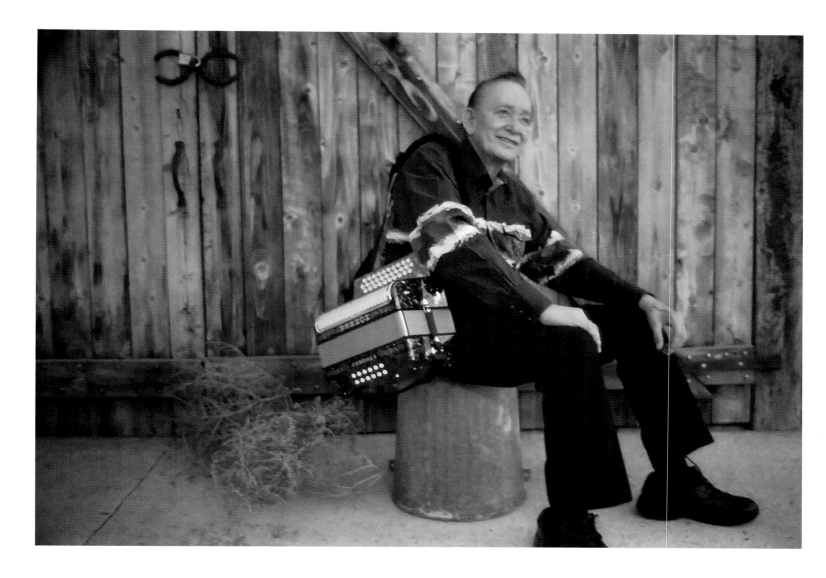

When I teach my Chicano Studies course, I ask my students to come up with a list of Chicano celebrities within any field of popular culture. They usually compile twenty or so names. But after we remove all the Puerto Ricans, Cubans, and Colombians from the list, there usually remain just about five or so Chicanos, who always include César Chávez, Dolores Huerta, and Selena. Yes, these three and several others, such as Ritchie Valens (Richard Valenzuela), Carlos Santana, Cheech Marin, Edward James Olmos, and George Lopez, certainly qualify as Chicanos who have "made it." Despite the fact that Mexican Americans make up the largest percentage of the Hispanic population in the United States, it is a challenging exercise for my students to do. And if Ritchie Valens and Selena had not tragically died before their prime, who knows what other milestones they would have reached?

I admit, I cried when I saw *La Bamba*. I also cried when I saw *Selena* and still do. Chicanos took Ritchie and Selena's untimely deaths very hard. Here were the two greatest pop cultural icons that the Chicano community had ever seen; and yet both died with too much left undone. We grieved their passings and lamented the gaping holes they left behind, never to be filled. But at least the films that portrayed their lives left us something to remember them by, even if they didn't star Chicano/a actors.

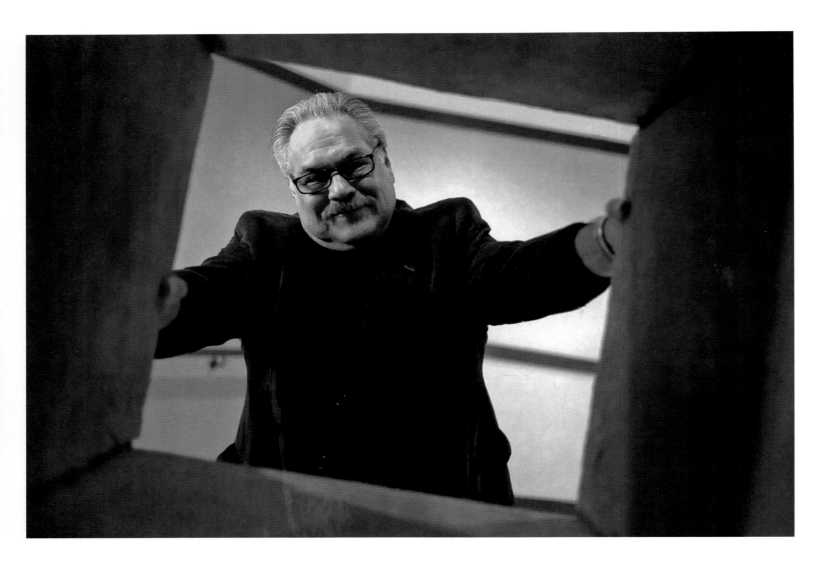

In the fall of 2010 I met a man whom I now add to my list of heroes. Luis Valdez gave the keynote speech at the Western Literature Association annual meeting in Prescott, Arizona. He confessed that he had almost declined the invitation to speak because of the blatantly racist anti-immigrant and anti-Mexican/Chicano policies promoted by the state of Arizona. He changed his mind after the anti-immigrant legislation was modified and U.S. Senator Raúl Grijalva called off a boycott against Arizona.

Valdez's lecture was enlightening as he moved us with his knowledge, convincing insight, and powerful baritone voice. The talk encompassed several different but related themes. He spoke of the racism against immigrants that has pervaded Arizona politics and much of the United States. He intertwined the geological, political, and cultural history of the Southwest, and of Arizona in particular, to show the absurdity of the current immigration debate. And he explained how the American public is aware of this history, yet actively ignores it.

He then proceeded to show how Hollywood has perpetuated racist beliefs by portraying Mexican men as bandits and greasers. During the early to mid-twentieth century, the bandido/greaser stereotypes fit Hollywood's need for movie villains in its growing Western genre. According to Valdez, these Mexican rogues were not quite Indian, but kind of Indian looking; not quite Spanish, but Spanish enough. In essence, the majority of Mexican men could fit this stereotyped look and play the part.

His message was simple, although it has not been heeded by Hollywood: it's time to portray Mexicans as something more than bandidos, greasers, and illiterate drunks and thieves. We are also fathers, mothers, lovers, honest and hardworking people, and even, from time to time, heroes. As the theatrical master who influenced Valdez's work, Bertolt Brecht, declared, "Unhappy is the land that needs a hero." Perhaps Chicanos are not in need of heroes, we just need to know that they exist.

He also spoke eloquently about the history of Arizona—of the whole Southwest—and its millions of years of existence and how over time its beautiful rock formations were slowly molded into the earth. In essence, the people of Arizona lived in an ancient place, and the new, misguided, xenophobic laws disregarded these facts of nature. He said that the Arizona lawmakers could not claim ignorance about our Chicano history, but rather it was ignore-ance: they ignored our history.

Throughout the course of this project I have been blessed to

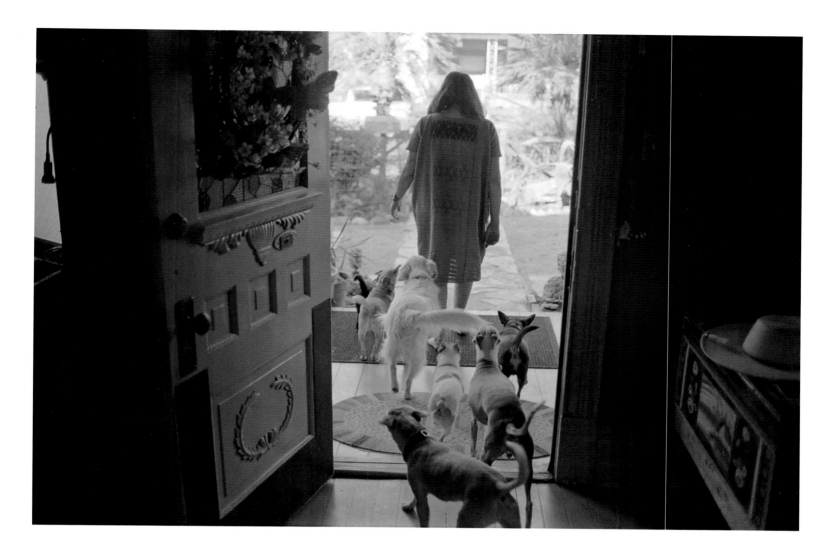

meet some of my heroes as they have graciously invited us into their sacred spaces. Author Sandra Cisneros openly shares her beautiful home in San Antonio with writers from all over the world, creating an environment that encourages community building and nonviolent social change. On the day we visited, it was like spending the afternoon with a dear friend from years past. As if it were a special occasion, she opened a bottle of Champagne and made a toast. Among friends and her family of adopted dogs, we felt welcomed. Sandra may have found that house of her own after all, but she made it a home for all those who are in need of one.

On another trip we met with one of the most significant U.S. authors of the last quarter century and the most celebrated to come from New Mexico. On a beautiful fall day Rudolfo Anaya kindly invited us to sit and talk in his kiva-style living room. While savoring a divine reposado tequila, as the sunset began to cascade across the Sandia Mountains, we enjoyed a lively discussion about the dual nature of Patrocinio Barela's famous wood carvings, the reception of the film based on his masterpiece novel *Bless Me, Ultima*, and his desire to make his books accessible to the everyday people who need them most. What I most fondly remember was the feeling of being in the presence of a man who had achieved literary greatness, yet was

humble and gracious. Upon our leaving, he wished us well: "*Que vayan con Dios.*" We felt blessed, indeed.

It is good to know that we have Chicana and Chicano heroes who give of themselves unselfishly and provide a sense of sacred space to those who seek them out. I have since concluded that the question I pose to my students about our heroes, asking them to look back into the past, has been too limiting. The ever-present teacher Señor Valdez often ends his talks by asking: "To whom does the future belong?" To which he responds, "The future belongs to those who can imagine it." I have learned that I should ask my students to imagine our heroes of the future, as well.

Gracias a los maestros Cisneros, Anaya y Valdez por habernos acompañado, aunque por un momentito, en el camino.

Like a Good Golden Drink

the sun went down this evening
as Ultima peered at us
her eyes shimmering like
reflections on glass
while constellations swirled

in a pool of carp and bosque leaves
and rusted cans in a heap of recuerdos
we sat in a circle contemplating
life's concentric forces and how

we set out in our youth in one direction
and the universe gives us a boot in the ass
and sends us reeling back towards another
we gather in a sacred space where

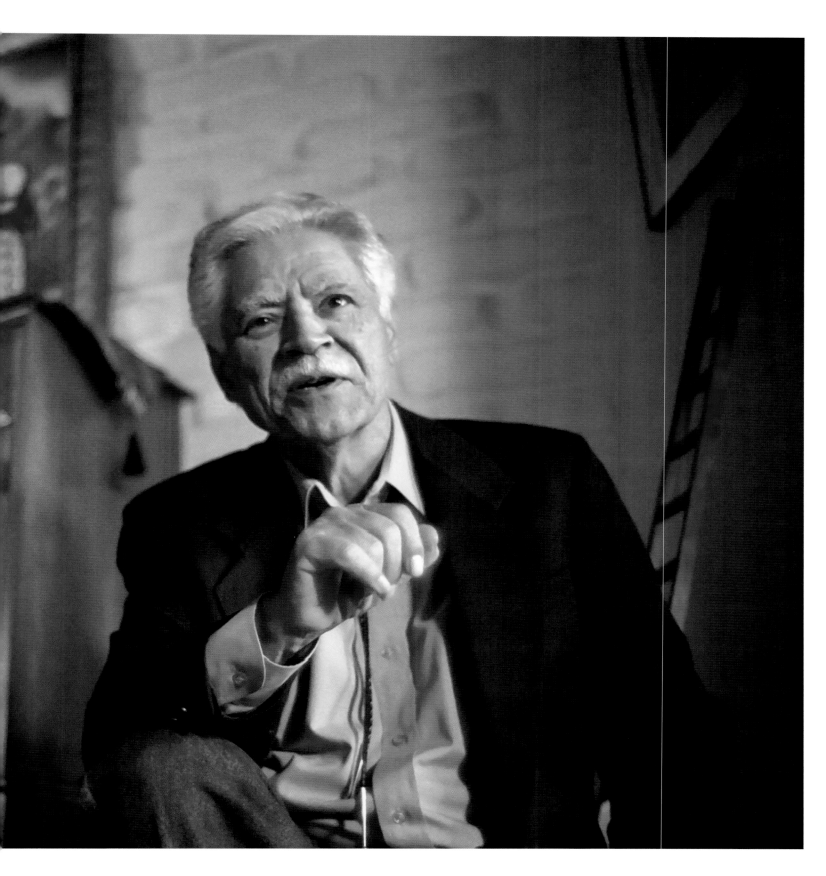

the duende resides in solitude
and welcomes us with a shot of tequila
Patrocinio's carving on the fireplace mantle
stands like an astronaut suited up
and ready to lead us out towards

worlds unknown undiscovered
someone enters the room
and we are shocked back
into the reality of another day down
another evening coming on

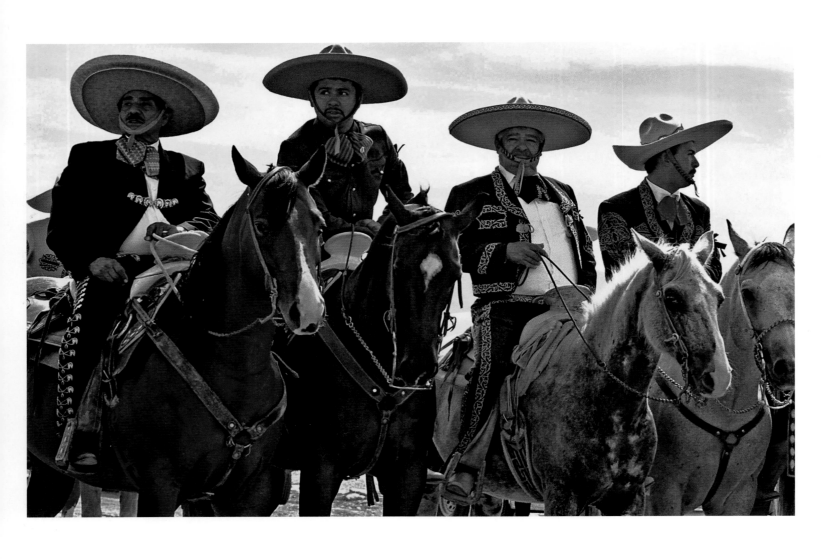

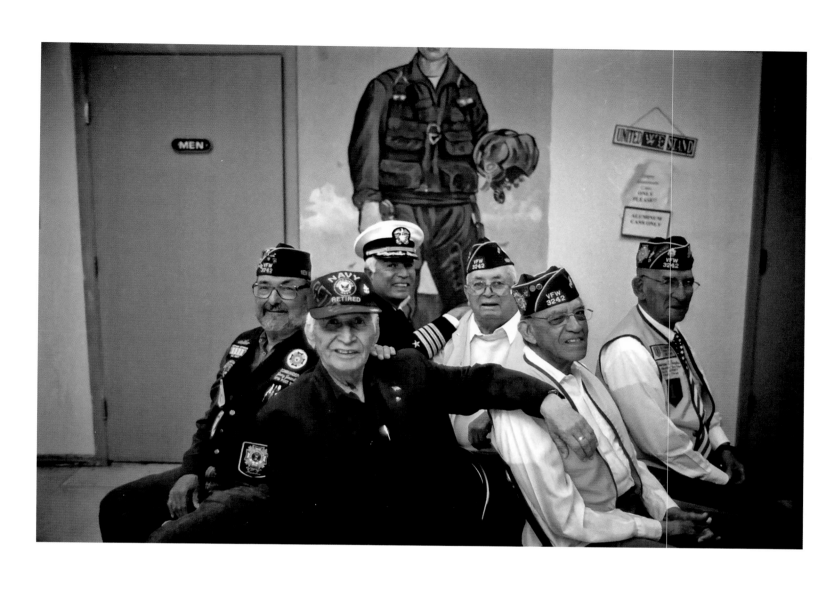

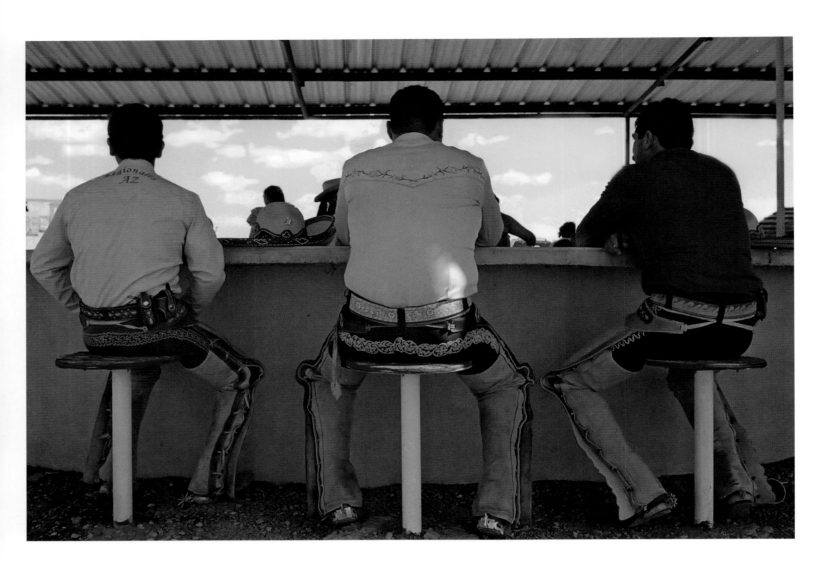

Still Life #3

maybe we should just write
and see what happens

and what if something does?
could we live with ourselves
if nothing did?

nothing has in such a long time
and yet that's a lie too

didn't you just laugh, smile
contemplate slicing my throat
as you reached for the butter knife
to cut up the pancakes?

and what if you had
sliced up my throat,
that is?

just as the transit bus
roared past
with cheers in the background
from the football game on the tv
rising in synchronized timing

the diner fans twirling
above the counter,
a fly darting between
its own negotiations

and the sloshing of the waitress
putting away the day's last pitcher
of iced tea

did you notice the evening clouds,
the multicolored patches of sky hemmed
against a blanket of crimson?

or the man walking down the street
his sunburnt cheeks
his aqua green Spanish-Basque eyes
veined with the need for a cure?

in just the minute that passed
the day went from dusk to night

sometimes nothing
is what happens
as the world wobbles by

like now, when the three men
at the other end of the counter trade jokes
the punch lines and the laughter
for themselves alone

you and I
are a jukebox
of sad stories

and we're down
to our last quarter

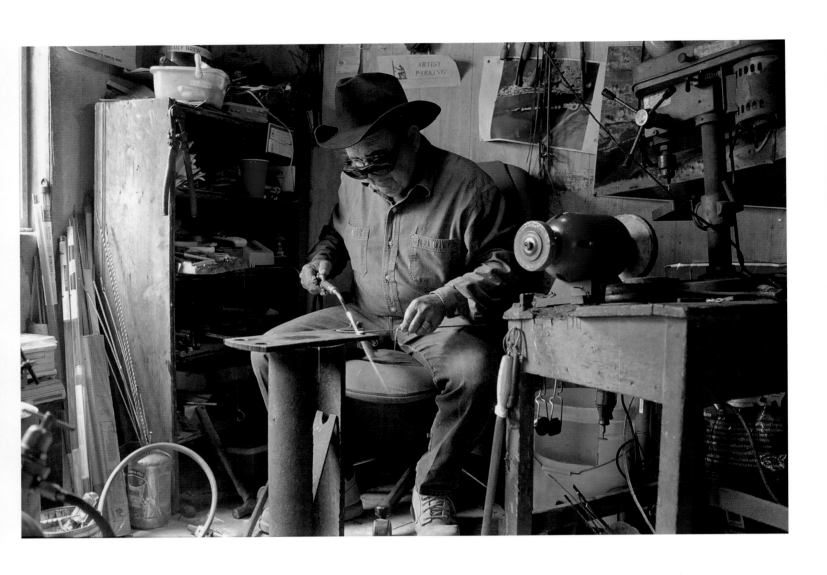

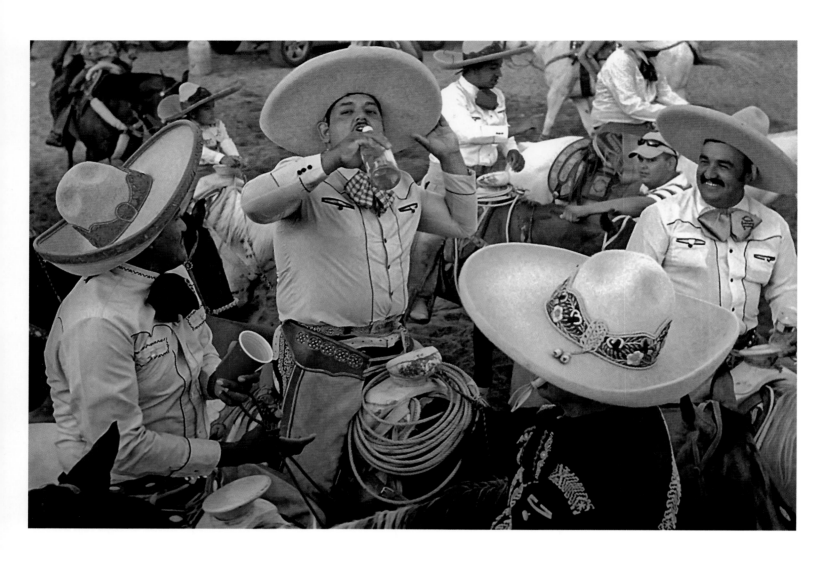

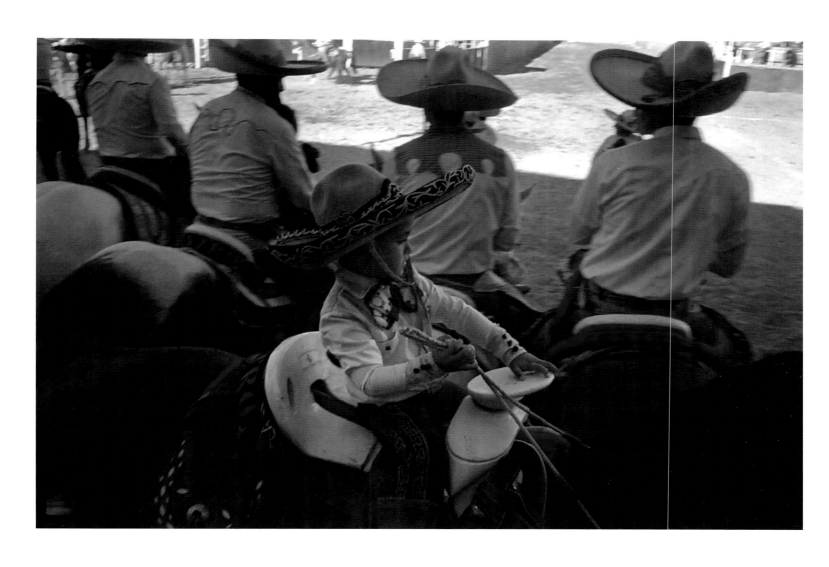

turn, turn, turn

i finally blocked the fallen cherry tree on Saturday
the trunk's diameter, a good forty-eight inches
cherry trees don't grow that big, do they?

later on i wrapped a cable
to the trunk segments
and pulled them out to the field
with the tractor

i couldn't help but think
my friend would one day
be asking for his cable back

how many seasons have we
worked that orchard together?

through late november's serenity
december's frozen calm
january's unpredictability
and april's poison ivy itching us along
we heaved, huffed, puffed, and laughed
our goat stubbornness
into piles of dead wood

yesterday i'm in the kitchen
the phone rings
and the afternoon comes to a pale stop

jr.'s in the hospital, he's in ICU
says a voice at the other end of the line
what happened? i ask
well, you know, he wouldn't quit drinking
damn! i say, looking out into the backyard

even springtime seems interrupted
the fruit blossoms about to pop

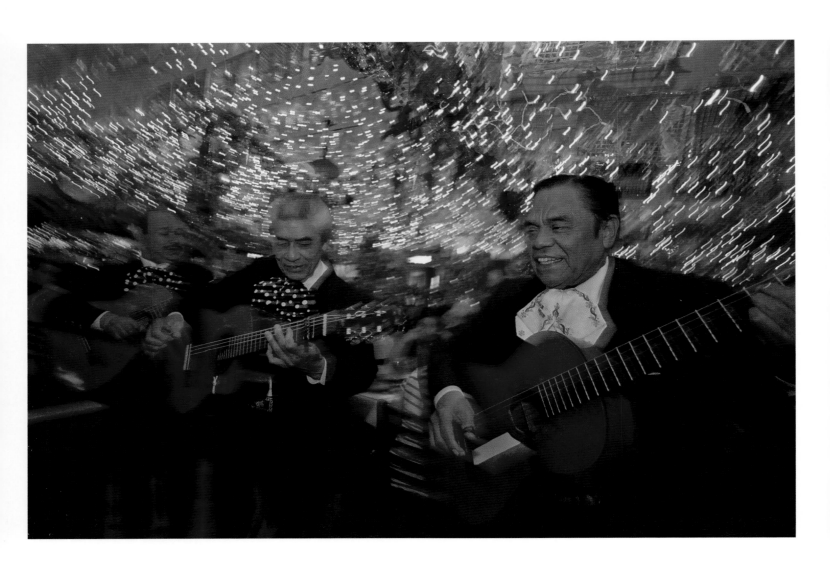

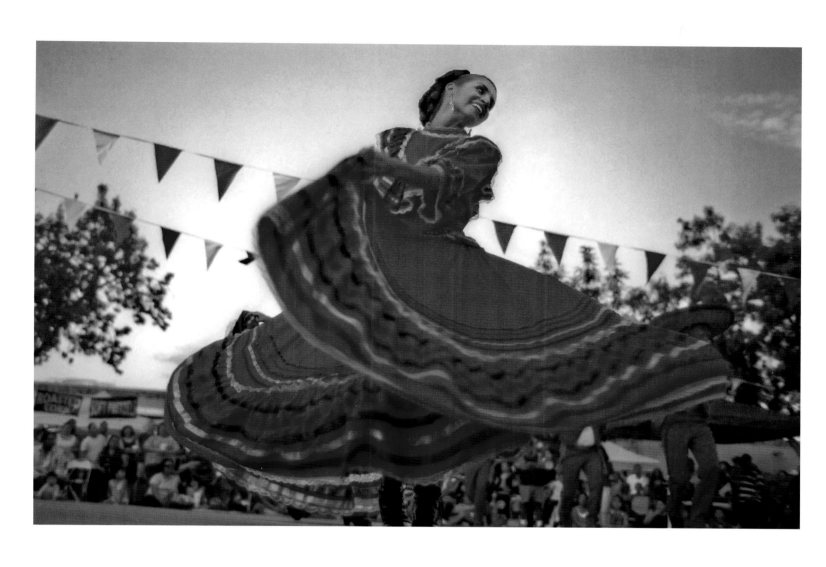

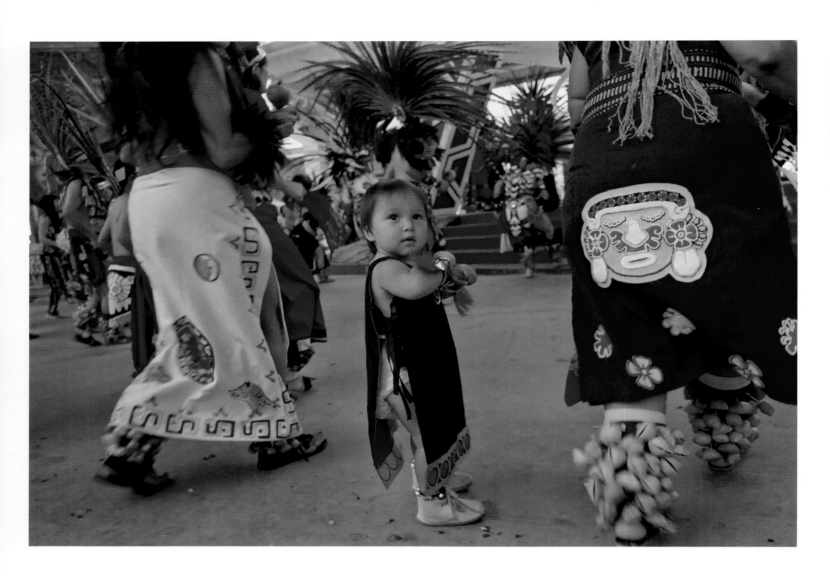

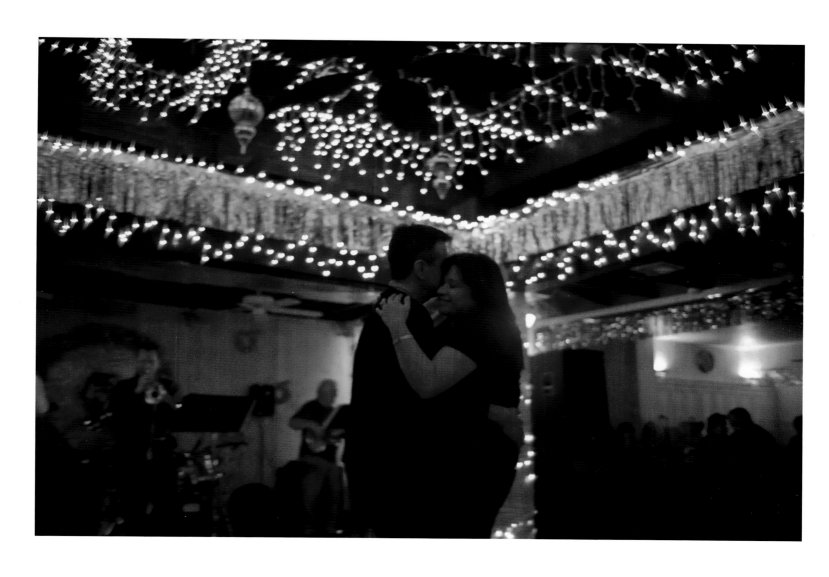

Ascension

some people take to picking up
refundable materials on the roadside
scouring for discarded objects through the weeds
and along the serrated edges of asphalt
using a recycled shovel handle and a rusted nail
held with a band of electrical tape to its blunted end

they sift for aluminum, plastic, copper
anything of inconspicuous value that has been
tossed out along the way
maybe even finding a fragmented
piece of themselves

I too carry my own bag of refuse
attempting to resuscitate inklings of poems
fragments of verses and stanzas
images and memories scattered like roadkill

tomorrow I'll head north
with the eastern light bathing my face
the past and the future swinging
like a pendulum from the rearview mirror

I'll make the sign of the cross
when I pass the *descansos*
their cross arms outstretched
embracing the sky like a hopeful mother
anticipating the return of her lost child

just above La Bajada Hill
I'll tune the station to KDCE Radio
the Mr. Ray Casias morning program
and the 9:30 a.m. *rosario* will be on
at ten o'clock the week's local obituaries
will be announced

years ago at the age of nineteen
just below the last rise of La Bajada
on our return trip home after
days of looking for work
Sonny, Abel, and I pulled over
to stretch our limbs
and catch a breath of the fall air

we trailed each other up a ravine
where we found a bottle
with the wind softly whistling
like a whispered promise
out of its small rimmed mouth
and we propped it up with a crude ring of stones

"so whenever we pass through here
we will always remember this day"
someone said, and we shook hands on it

from the edge of the barranco
we looked down at the hazed valley
Abe's faded, baby-blue '62 Ford Falcon station wagon
stared up at us, bumper sad and road weary
at our feet, shards of glass glistened
against the red of the earth

at a roofing company trailer
miles behind and days before
we had filled out job application forms
and were hired on the spot
then told to sit in the lobby and wait
for the crew boss to instruct us
on where to go and what to do

we had just sat down to wait
when Sonny picked up a guitar
wedged into a corner and began
plucking the three chord intro
to "Sweet Home Alabama"

The red-haired, freckled-face receptionist
who just minutes before had offered us coffee and donuts
stormed into the lobby unleashing a torrential verbiage
of insults, her voice whipping against the thin, wood-paneled walls
like a lightning bolt of crackling profanities
and sounding like the lecturing teachers we thought
we had forever left behind when we had dropped out
of high school the spring before

"don't you know you ain't suppose to pick up
someone's guitar without asking fer their permission?
you dumb fools, get your asses out've here!"

wham! out the door we went
into the cold morning chill
hollow stomach hungry and our necks twisted
from nights of sleeping in the car
¡pendejo, safa'o! cursed Abel
and slapped the baseball cap off Sonny's head

and maybe that's just the way
it's supposed to be for guys like us
a life of going upward on a downhill road
climbing against impossible odds
and always ascending toward the unknown
against the mountain of struggles
we bring upon ourselves

leaving pieces of this and that along the way
little crumbling reminders to guide us
back to where we started, back to our kin
back into the embrace of those
who will welcome us as we are

lost children, discarded, fragmented
with a crazy ol' song in our head
and the hum of hope, faith, and promise
leading us over the next rise
and extending itself out
like a friend's hand
to pick us up when we're feeling blue

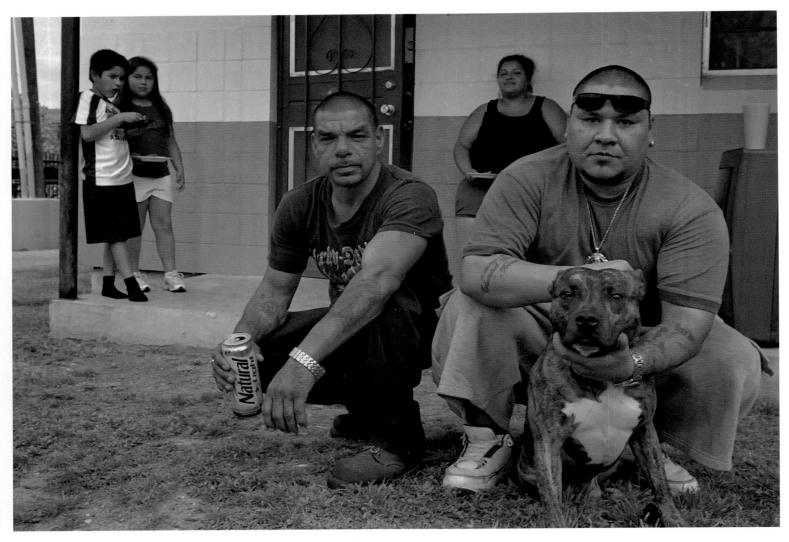

Mi vida loca

What you lookin' at, ese?

 —Badass vato

I was never a troublemaker. I never wore white Converse high-tops, flannel shirts with only the top buttons fastened, or a bandana tied around my forehead just above my eyes. I never sat in the back of the class drawing lowriders or pinup girls. And I never carried a knife, brass knuckles, or a sharpened wooden object made in shop class. But I knew plenty of guys like these where I grew up, and I was afraid of them.

At Burbank Middle School in Houston, gangs were a problem. Daily, during the last period of school, the principal would remind us over the intercom not to walk in groups of three or more upon leaving the school grounds because we would be considered a gang and consequently arrested. Although I was not part of a gang, I was aware of the menacing image that they had formed—or that had been created on their behalf. I was not sure what I feared most: The possibility of being arrested for "impersonating" a gang member if I had been caught hanging out with my friends? Or getting beaten up for giving someone the wrong look or for appearing to think that I was better than someone else? In retrospect, I feel that the school administrators exacerbated the problem by creating a climate of fear around gang-related activity.

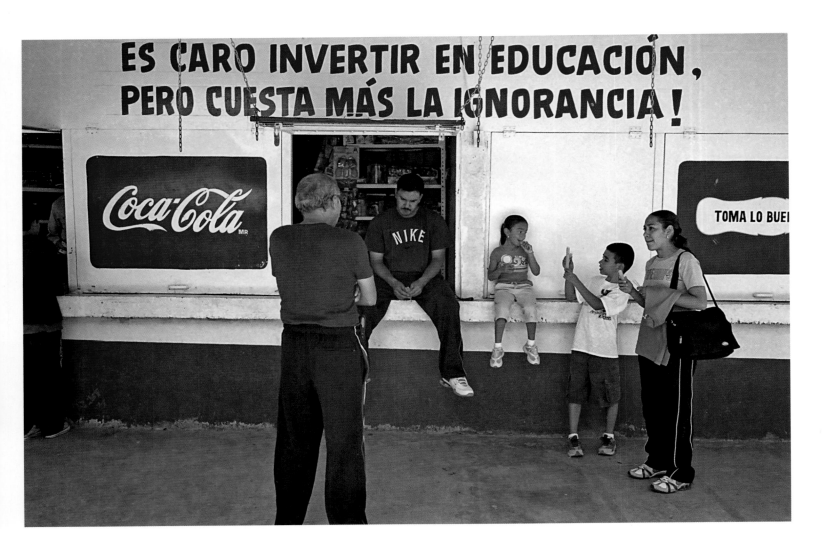

For the most part, I don't think that gangs of twelve- to fourteen-year-old boys and girls were really that big of a problem. The difficulty was really that school administrators and teachers did not know how to properly address the root issues. One thing is for sure: the students were not the problem. Gangs were rather a symptom of something more serious. These adolescent boys and girls suffered from a lack of identity, and so they created one that they could share and even flaunt. It was not their fault that they did not know their own history. Schools, libraries, teachers, and society in general had failed them in this regard. Without the knowledge of who they were and what their past and culture meant, how could they take pride in themselves? Logically, they needed to invent an identity that they could claim as their own.

This desire and need to carve out a social and cultural space is nothing new for people of Mexican heritage. Even in México, a Euro-centered curriculum has almost always been favored over one pertaining to indigenous or mestizo culture. Although México's people derive mostly from non-European bloodlines, it is the Spanish language and Catholic religion that have permeated Mexican culture. In similar fashion, the French have also heavily influenced México, especially in the areas of

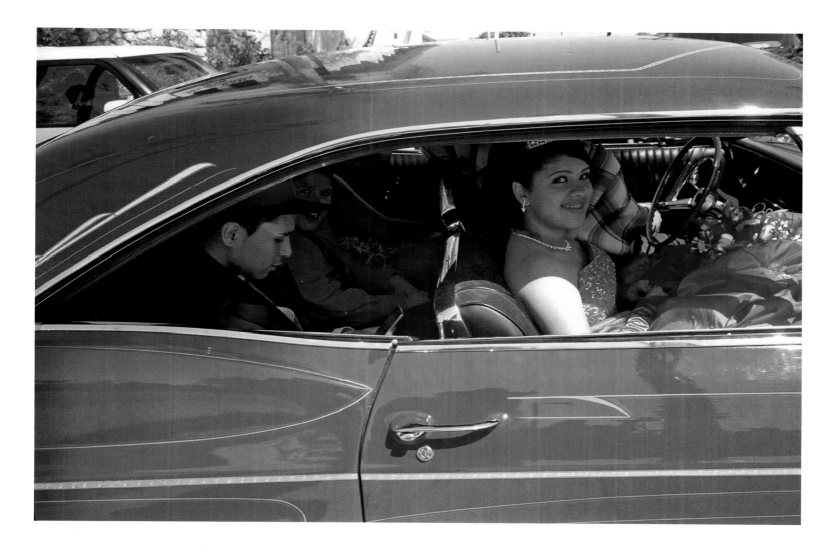

architecture, law, and food. This Mexican preference for Occidentalism, particularly by the aristocracy, split the country when France usurped Mexico's first indigenous president, Benito Juárez, in favor of the Austrian-born Maximilian von Habsburg during the French intervention of 1861–1867. France may have invaded to recover a debt, but in truth it was another attempt at cultural conquest. Ironically, Porfirio Díaz, who led battles against the French, who later ruled México from 1876 to 1911, and whose mother was Mixtec Indian, encouraged German settlement to "improve" the stock of the Mexican people. This culture clash came to a climax during the Mexican Revolution from 1910 to 1920, at the height of the period when México was wrestling with its national identity.

A by-product of Mexico's domestic revolution was the idealistic call for the creation of a fifth race—one composed of all the other races—posed by José Vasconcelos in his 1925 book *La raza cósmica*. Despite his intentions, in reality Vasconcelos's proposal meant that Indians were to assimilate and become more Mexican by changing their language, dress, and customs, and not that mestizos were encouraged to embrace their indigenous heritage. In light of Mexico's struggle for a cultural identity, how could a strong Mexican national pride based on

creating *la raza cósmica* ever develop alongside the often overt cultural and genetic aspirations of the bourgeoisie and their desire to marry whiter or, as many Mexicans have often declared, *mejorar la raza*? A new, bronze race may have worked as an intellectual ideal, but a whiter race and culture has traditionally been preferred over that of the *indio* and even the mestizo. The desire to improve the Mexican culture went beyond blood; it meant shedding the sense of historical inferiority associated with being indios.

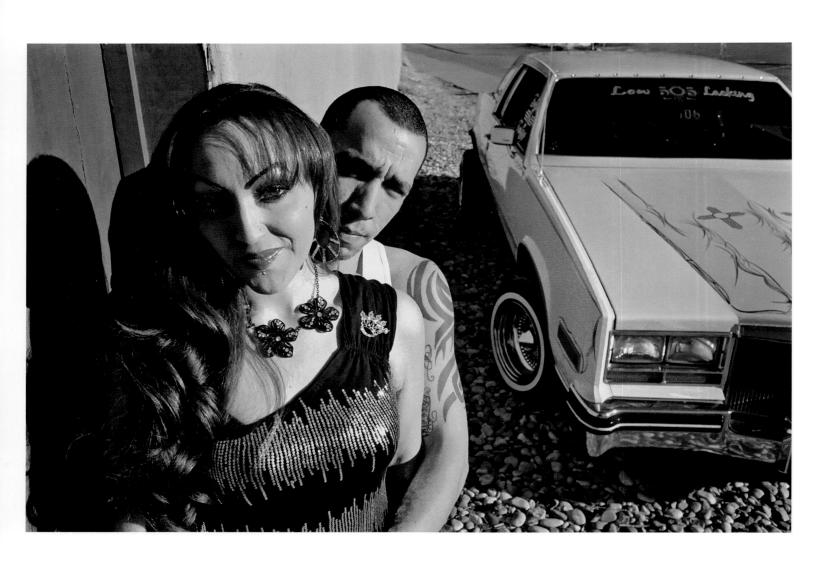

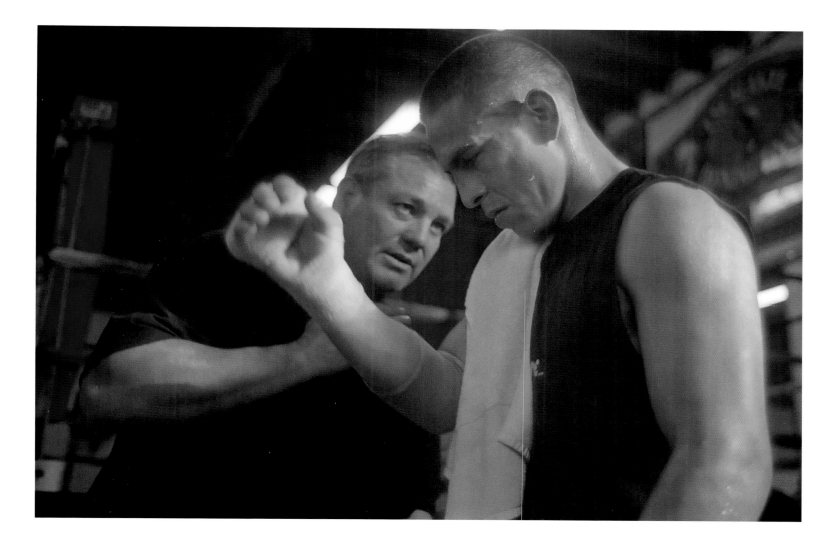

Samuel Ramos, one of the first Mexican scholars to address the issues surrounding the Mexican psyche and cultural identity, examined this point in his 1934 ethnopsychological study *El perfil del hombre y la cultura en México*. Ramos attempted to debunk the theory of the Mexican inferiority complex as a rule of nature. He argued that Mexicans are not inferior; rather, they have been made to feel this way through a process of repeated actions that have successfully implanted this notion within the collective Mexican psyche as if it were fact.

Ramos understood many of the underpinnings of what he deemed the origins of the Mexican inferiority complex. He theorized that the principal factor contributing to this collective psychological complex was the failure of Mexican schools and teachers at all levels to draw a connection between studies and life. He believed that students should be educated to enhance their knowledge of México, noting that Mexican students are notorious for graduating from the university knowing a great deal about other countries and cultures but virtually nothing regarding their own. The same is true for the many Chicano students who have received only a sparse formal education in all things Chicano and consequently have suffered from a similar sense of inferiority.

This inferiority complex was also noted by Octavio Paz, who studied pachucos while he lived in Los Angeles after World War II. He saw pachucos as Mexican American youth who rebelled against being American but did not want to return to being Mexican, either. For Paz, they did not quite fit into American society, and not completely because of their looks, but also because of their actions and attitude. Paz noted that what distinguished them was their furtive, restless air and their clothes, which served as a disguise. They appeared tough, but feared a stranger's look because it could strip them of their masks and leave them feeling naked and vulnerable. Although Paz's anthropological observations were astute, he did not see pachucos as individuals, only as a group to be observed from a safe distance.

Los Heroes

los watchávamos
cuando pasaban
echando jumito azul
en sus ranflas aplanadas
como ranas de ojelata

eran en los días
de los *heroes*

cuando había *heroes*
turriqueando en
lengua mocha
y riza torcida

Q-vole

ahora nomás pasan
los recuerdos
uno tras del otro
y mi corazón
baila

bendición

bendición es
estar contento

Señor, gracias por . . .

gracias por todo

Luis Valdez, on the other hand, is a Chicano playwright who has studied and understands the Chicano psyche as well as any other authority on the subject. As a scholar, Valdez certainly picked up on Paz's ideas and incorporated them into his plays. But more importantly, as a young Chicano who grew up in California during segregation and the Zoot Suit Riots, Valdez understood this rebellious nature firsthand. In his play *Zoot Suit*, the pachuco character is beaten up by a group of sailors, who rip apart his zoot suit and leave him almost naked in the street. He is essentially stripped of his mask and his identity by strangers and left with nowhere to hide—his worst fear, according to Paz. Whereas Paz defines these young men as cultureless individuals with nothing to offer society, Valdez sees their value to the community. They represent the young men and women who are a bridge between their Mexican past and American future—but in the present don't quite fit into either realm. Alone and pitted against the world, they must look inward and to each other in order to find strength to survive. Together they have developed a sense of group identity that shares language, history, and place.

In the more than seventy years since the genesis of the zoot suit culture, the stoic archetypes have transformed from zoot suiters and pachucos to lowriders to today's cholos. The attraction of this lifestyle has not changed. Gang life has always been a draw for those who don't quite conform to mainstream society. And the stare from a stranger still puts them on guard. In fact, a few years ago I was eating breakfast at a restaurant in Albuquerque when an Anglo man stared one second too long at a tough-looking Chicano. The Chicano was quick to come to his own defense and used a firm voice to set the other man straight: "Whatcha looking at?" Caught by surprise, the Anglo man was noticeably frightened. He apologized and turned his gaze away. This Chicano would not be stripped in public, and he made sure that everyone in earshot knew it.

These are not isolated cases. With every generation, thousands of men and women are made outcasts of society because they do not fit the norms. They were born and raised in the wrong place. They spoke the wrong language. They hung around the wrong people. Just about everything they knew led them down the wrong path: detention, expulsion, dead-end jobs, prison, and drugs. For some, their only saving grace was their attitude: "*Soy quien soy. ¿Y qué?*"

One good example of this phenomenon is the prominent Chicano poet Jimmy Santiago Baca. Abandoned by his parents at the age of two, he was turned over to his grandmother's care. At thirteen he was placed in an orphanage, from which he ran away. With nowhere to go, he lived on the streets and was eventually arrested for the "crime" of being homeless. At the age of twenty-one he was convicted of drug charges and spent six years in prison. After one fateful incident with another inmate who had threatened to kill him, Baca looked to literature to turn his life around. He went on to write many

wonderful books and even directed a film, *Blood In, Blood Out*, about gang life in San Quentin, a prison where he once did time. But the personal voyage from being a homeless chicanito to an award-winning Chicano author was a long and serendipitous one.

Like almost all Chicanos, Baca had never learned about who he was, his people and their history, in any formal setting. In fact, he claimed he did not even know that Chicano history existed. This all changed one day in the prison library when he ran across the book *500 Años del pueblo chicano/500 Years of Chicano History*. Fortunately for Baca, who could not yet read, it was a book of pictures depicting Chicano culture since the days of the Spanish conquest through the Chicano movement. For the first time in his life he discovered he and his people had a history that they could proud of. He was so enthralled by the book that he stole it, ironically while in prison, to share with his fellow inmates and show them that they indeed existed. Exposed to a world of possibilities, a poet had been born.

As Levi Romero notes in "Lowcura": "The vato loco bore not only the burden of his own individual identity, but also sustained the cultural traditions of language, religion, spirituality, and allegiance to community." Although he is a hero to some, the vato loco is a societal menace to many people, who see only the mask and the furtive look. They're *traviesos* whose guarded emotions are revealed only through their teardrop tattoos. If it were up to the Sheriff Arpaios of this world, they'd lock them up, clothe them in pink jumpsuits, and make them pay for all the crimes we can imagine they did. Truth be told, it's a good thing for us Chicanos that the vatos locos exist. For all the times I wanted to fight, for the words I wanted to say, and for the looks I wanted to give but never had the courage to do so, the vatos locos did it for me. They took the heat and paid the price for the deeds we secretly desired to do. There's a reason why many of us fantasized about strutting the right clothes, cruising in a lowrider with a fine ruca, kicking someone's ass and bragging about it, using the words *órale*, *simón*, and *suave* all in the same breath, and playing the part of the pachuco, lowrider, and vato loco. They represent what almost everyone wants to be—themselves.

Familia

Hey Keyser, mira, ven pa'ca

the kids in the neighborhood told me
one day after school

i was twelve years old

you wanna be a pachuco
like us?

they asked me

what's that?
i replied

it means "familia"
they said

and pulled out a needle
and some India ink

No hay honor
más dulce

En las palabras de un homie,
José Alfredo Campos, 1962–2007

"mi destino
me puso en el camino
de la vida loca

pero hoy en día le busco más
al corazón y menos
al desmadre

aquí en estos lugares
todos los días
traen nuevos vientecitos
de guerra

no nos queda otra, homie
apretar los dientes
y no dejar caer la bandera

aquí se calan los hombres
y siempre manejamos caminar
con dignidad y respecto

no hay honor más dulce
que el que se compra
con sangre

y como dice un pelado
vivir es sufrir
y lo que nos cae bueno
es gravy

arrevata todo lo bueno
y acuérdate lo que dijo
el Ivan del Embudo

kiss my ass nobody!"

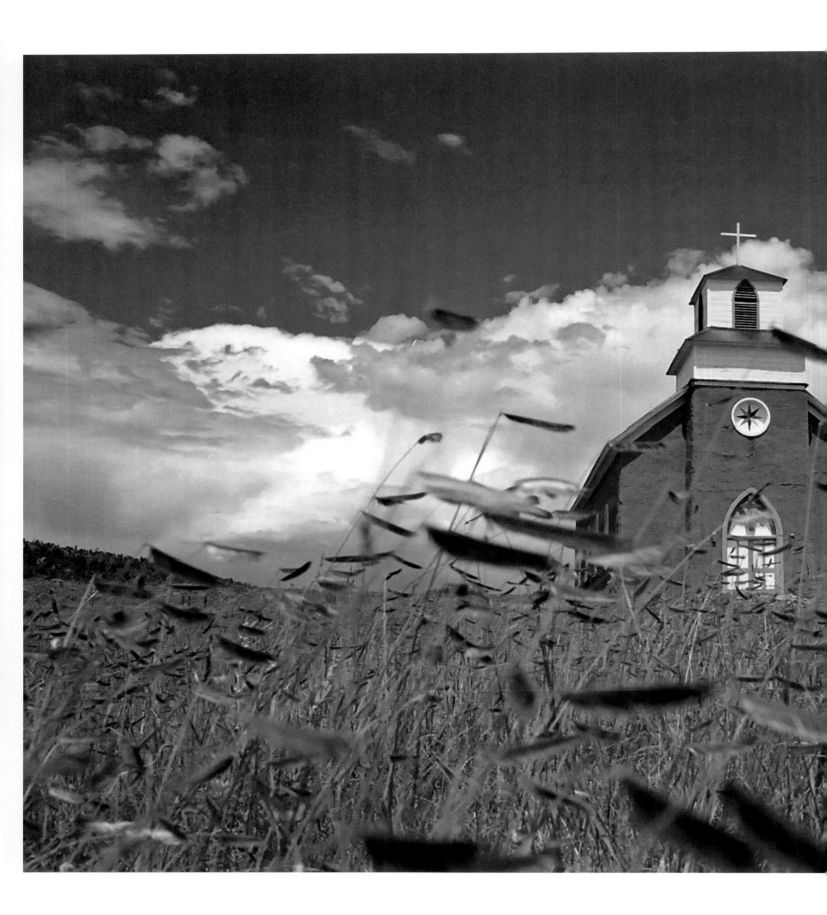

El norte
más allá

Open up any travel magazine that boasts about the wonders of the Land of Enchantment and you'll read about the choice of "red or green" on your favorite Southwestern dish, the fusion of Native American, Hispanic, and Anglo cultures, and the historic Route 66. It is true, all of these cultural elements can be found in the state, but Nuevo México is much more than a cliché on a postcard. It is home to ancient civilizations with deep roots. It is a land of cultural *mestizaje*, where people and traditions have mixed across generations. This is a sacred place with a long memory.

This is the land where Acoma, the longest continuously inhabited community in the continental United States, has existed since the thirteenth century. This is the land where Santa Fe, the first capital city in the modern-day United States, was founded in 1610. This is the land that the "Last Conquistador," Don Juan de Oñate, settled with a brutal force and where he created a memory with scars that get reopened with almost every generation. This is the land that became the forty-seventh state in the union in 1912, delayed for over sixty years because several politicians in Washington felt that there were too many Mexicans and Indians. This is the land that before it was American was Mexican; before that, was Spanish; and has always been Indian. This is la Nuevo México.

———————

I remember when I first crossed the Sandia Mountains going west on I-40. With a small trailer in tow, I was embarking on a new adventure. The mountains, the forests, the high desert—it all seemed so majestic. However, coming from Houston's Gulf Coast, I found two things difficult to adjust to: the dry atmosphere and the abundance of the color brown. I grew up with high humidity and the color green. Green trees, green grass, and green plants grew everywhere in Houston. By contrast, the color brown dominated the Albuquerque landscape: brown dirt, brown grass, and brown houses. Everything seemed to be a shade of brown. I had no idea just how important rain was to this region. Where I was from, it could rain sheets for hours and then again the next day and nobody would think it unusual. Now I found myself tuning into the nightly weather forecast on a regular basis. *Dew points, monsoon season,* and *snowpack* became part of my vocabulary. For the first time in my life, rainfall, or the lack thereof, seriously concerned me. How could life survive without enough rain?

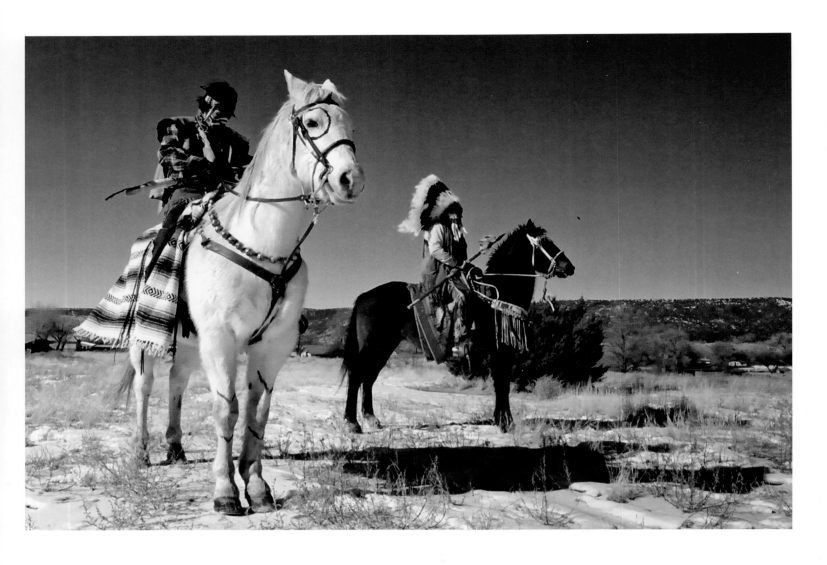

As it turned out, New Mexico had no problem sustaining life, even with scant rainfall. For what New Mexico lacked in rain and green vegetation, it more than made up for in other areas, especially in culture. In Texas we had Tex-Mex food and Tex-Mex music, but many of us had lost other significant parts of our culture, particularly a connection to our indigenous heritage. Mirabeau B. Lamar and the Texas Rangers made sure of that. Lamar was the second president of the Republic of Texas, who famously said that the only good Indian is a dead Indian. Under Lamar's presidency, Texas Indian policy was one of erasure. It was illegal to be Indian in Texas. And to think, my high school team mascot was called the Lamar Redskins.

Only a handful of tribes survived complete annihilation during Texas's early years as a republic and later a state. The three federally recognized nations that still exist today are Ysleta del Sur Pueblo, which broke off from the original Isleta Pueblo in New Mexico after the tribe was forced to flee to El Paso in 1680 with the Spanish settlers; the Alabama-Coushatta nation, north of Houston, which received reservation land from Texas's first president, Sam Houston, as part of its treaty for not intervening in the battle for Texas independence; and the

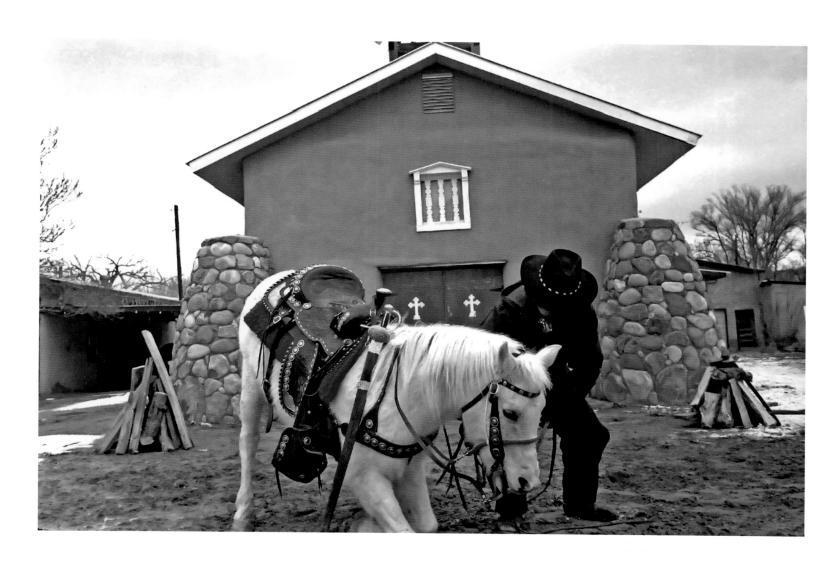

Kickapoo, which originally migrated from the Great Plains, but settled in south Texas and even lived for years under the international bridge on the U.S. side between Eagle Pass and Piedras Negras. Other than members of these three groups, almost all other Texas Indians were either killed, fled to México, or became Mexican overnight. Many traditions, languages, and entire groups of people vanished into the history books.

Taos Nicho

¿tus santos y tus velas
qué me salvarán?

sin la cruz
no hay gloria

pero como dice mi Hermano Juan
todos quieren la gloria
pero nadien quiere la cruz

indigenous mother
encased in the dead dust
of permanence

how fast the world
 goes us by
shadowy and flapping
like the clothes on the line
 in the backyard
 off a back road
 in Ranchos

the sky darkening
along the edge of the mountain
autumn storm clouds approaching

slowly

as if set and framed within
a landscape interpretation
of an oil or pastel

to what direction
 should i cast out my prayers?

the sun comes up still
 to the east

but my life is disoriented

my feet are fast and swift

but with no direction
no intent, other than
in the getting there

i feel like the Indian dancer
in the painting
whose headdress and plumes
are frozen
 and whose gaze
 has been blushed out
 by a well applied
 brushstroke

it is in the what
 is not there
 that one can find what is

on this day, en este día
el Día de la Asunción de Nuestra Señora

i watched footage
of last summer's parade
on the local TV station

watched the young fiesta queen
 white gloved and crowned
 waving her hand
 flicking her wrist
 in perfect motion

to the crowd along
the procession
as they do
in events and places like Macy's
or Pasadena

and the young caballeros
on their stout horses
trailed behind

yelling through perfect teeth
 ¡Que Viva la Fiesta!

dressed as conquistadores
wearing their new grown beards
and the latest style of sunglasses

and i thought of the Pueblo down
 road
and what its people
must feel for this
 reenactment

and i am everything at that point

and nothing

for i feel joyous and celebratory
for we have endured

my people
mi raza
los manitos

la huerfandad

the orphaned ones

whom Spain abandoned
Mexico did not adopt
and the U.S. never wanted

and i feel the sorrow of the *Indio*

because of that
 enduring

and my heart
 if it could be captured
 painted and displayed
 exhibited in the finest gallery
 where the locals do not enter

would be earthen, grayed
and splintered
a tinge of red perhaps
colors of
 the wooden crosses

tilting in their final balance

in the *camposantos*
 among the ruins
 of those first *iglesias*

destroyed in the Pueblo Revolt
 of that not
 so long
 ago

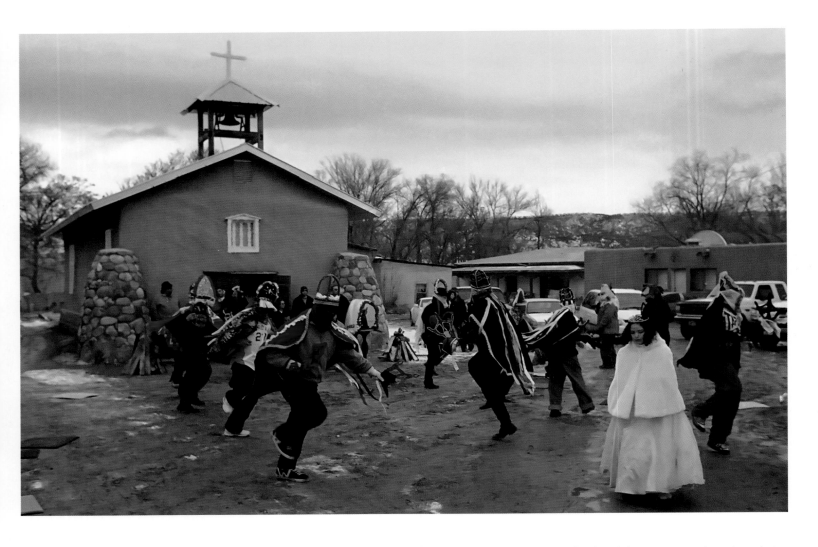

New Mexico, on the other hand, has maintained a rich tradition of Native American culture. With nineteen pueblos and different groups of Navajos, Comanches, Apaches, and Utes, New Mexico remains Indian country. Many languages are spoken, traditional ceremonial dances and songs are performed, and foot races, pole climbs, and *travesuras de payasos* take place on feast days. New Mexico owes its soul to the Native American people. Without them, the state would be just like many others in the union, homogenized. But New Mexico is quite the opposite; it is heterogeneous in its cultures, languages, and bloodlines.

One group that is proof of the state's unique mestizo past is the Genízaros, an officially recognized indigenous people in New Mexico. Genízaros were Indian slaves in provincial Nuevo México who served as laborers, sheepherders, and, perhaps most importantly, buffers from Comanche and Apache raids; their settlements on the periphery of Spanish land grants protected the Spanish villages. Most Genízaros were captives from other tribes, such as the Navajo, Pawnee, Apache, Kiowa Apache, Ute, and Paiute, or from the Hispanic communities. Genízaros were commonly sold as slaves to other tribes or Hispanic households. Many key villages were heavily influenced by Genízaro settlements, including Tomé, Socorro, and Abiquiú. But two northern New Mexico villages in particular have maintained a strong connection to their Genízaro roots: Ranchos de Taos and Talpa.

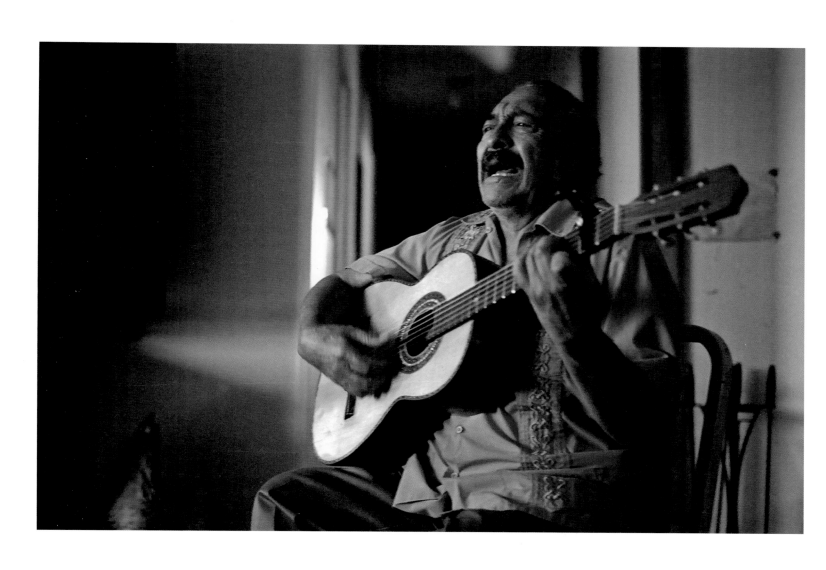

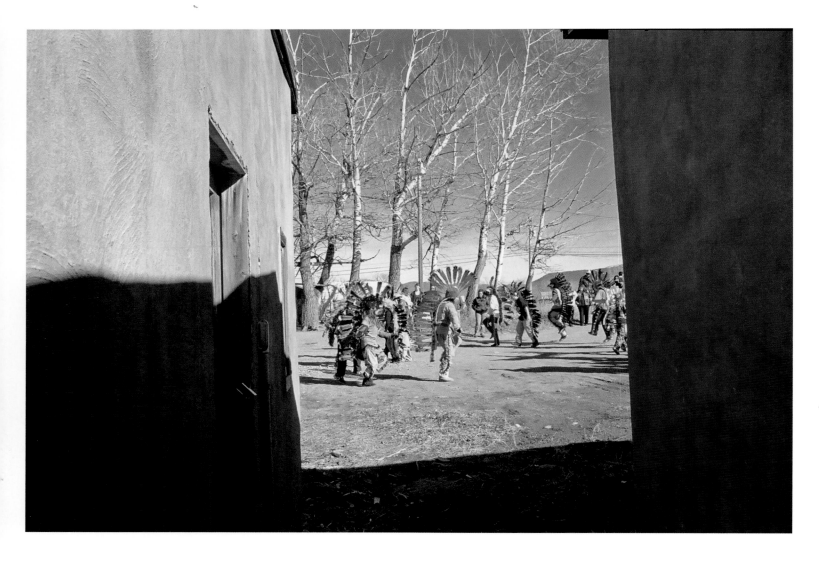

This particular group of Genízaros is called Los Comanches de la Serna. They have lived for centuries in and around the area of the Serna land grant. They are Hispanicized Indians who come from the Comanche tradition. For centuries the Comanches ruled much of Colorado, New Mexico, and Texas. Their raids were infamous. The Spanish and later the Mexicans feared them. The Pueblo Indians were equally at their mercy. They came for corn and other food products, stole horses to restock their herds, and took women and children as captives to replenish their own numbers. Legends and *inditas* (songs about female captives) recount their might, mourn the loss of life, and grieve for the women and girls who were taken. However, they were not strictly fierce warriors or cruel enemies. They also believed in community egalitarianism. In anthropological terms, the Comanche people were considered a flat society. Unlike the Pueblo people, who had hierarchal community structures, in Comanche culture just about anybody could achieve a respectable status, even Genízaros.

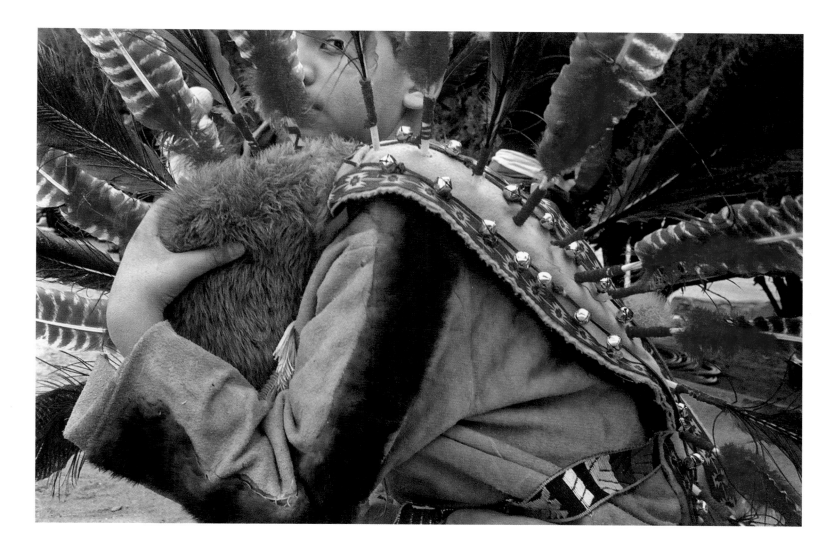

For Comanches, what earned respect was one's bravery and character. Regardless of their past or origins, through their actions Genízaro captives were thus able to achieve equal status as citizens within their group. In fact, many Comanches, such as Quanah Parker, the last great Comanche chief and son of Chief Peta Nocona and Cynthia Ann Parker, were captives or the offspring of captives. This was also the case for the Comanche Genízaros who lived in northern New Mexico.

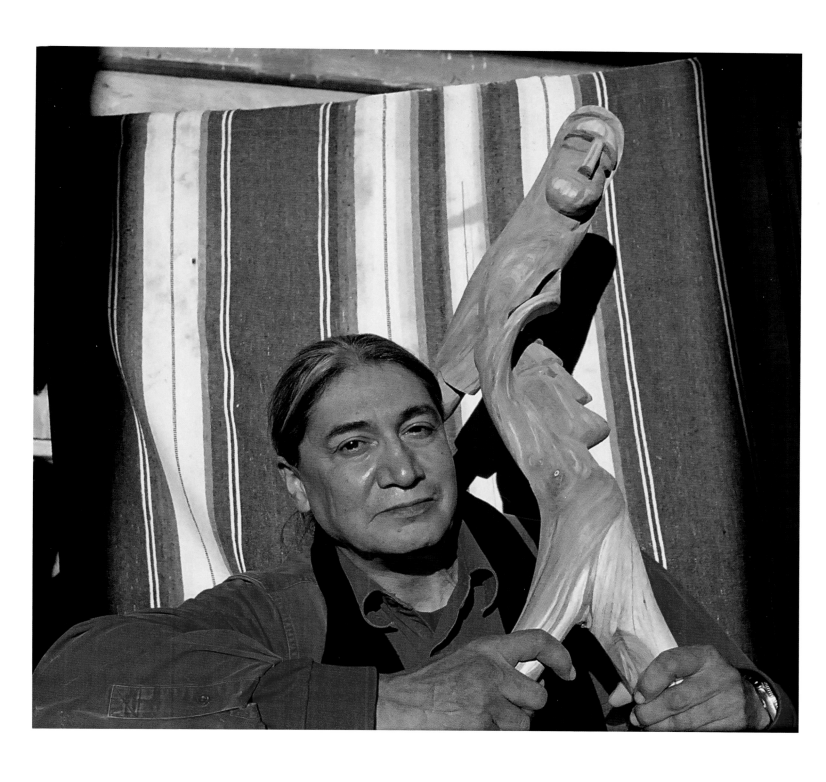

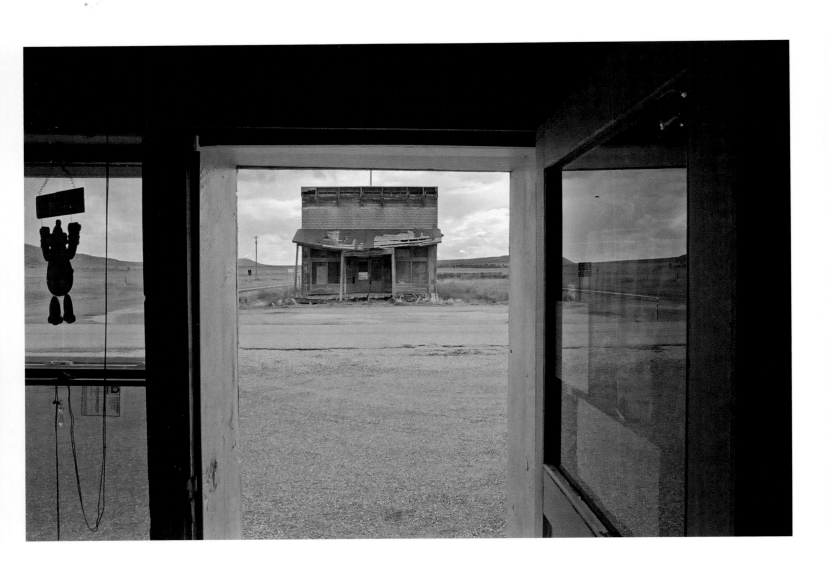

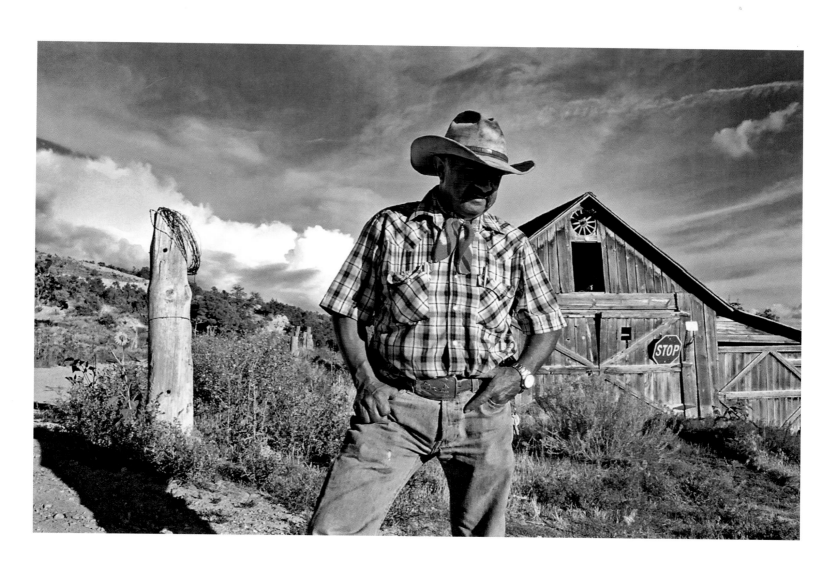

Daddy's Old Trucks

at night we
would sit with
our father

at the kitchen
table where he
would draw

antique cars and
trucks for me
and my brothers

daddy what does
a '32 Chevy
look like

what about a '34
Ford, daddy now
draw a Model T

and we would ask
him to draw
old trucks

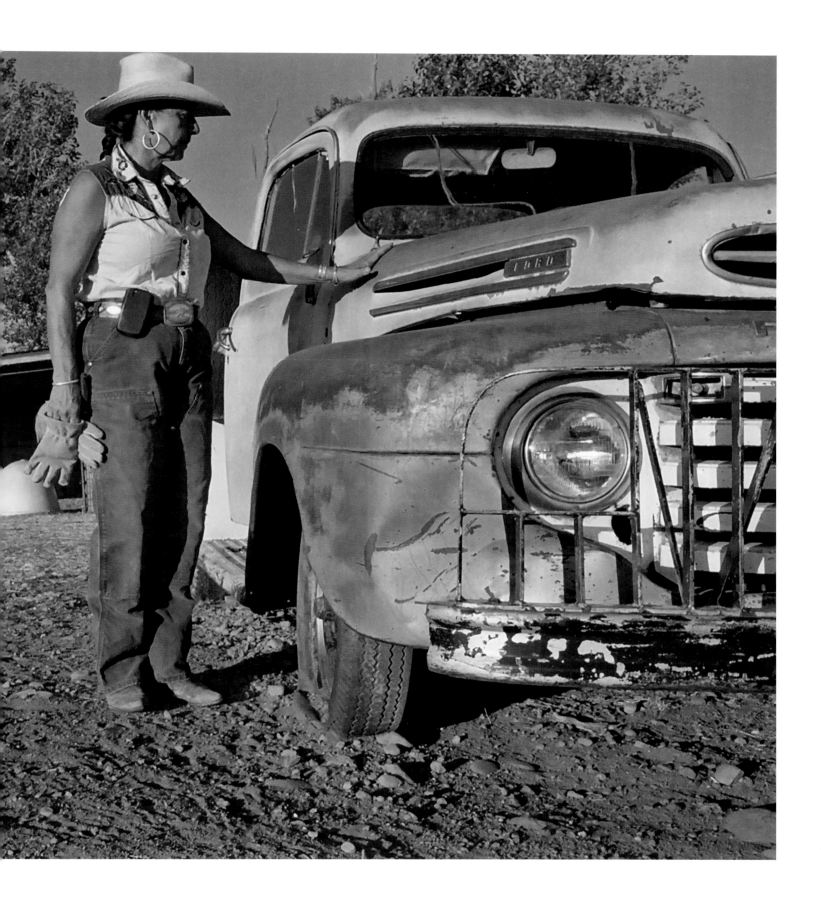

like the one that and some of the kids because we didn't in class I because I drew
our teachers mocked were reluctant to own a new car would be made too many old cars
him for driving be our friends or truck to stand in the corner I remember

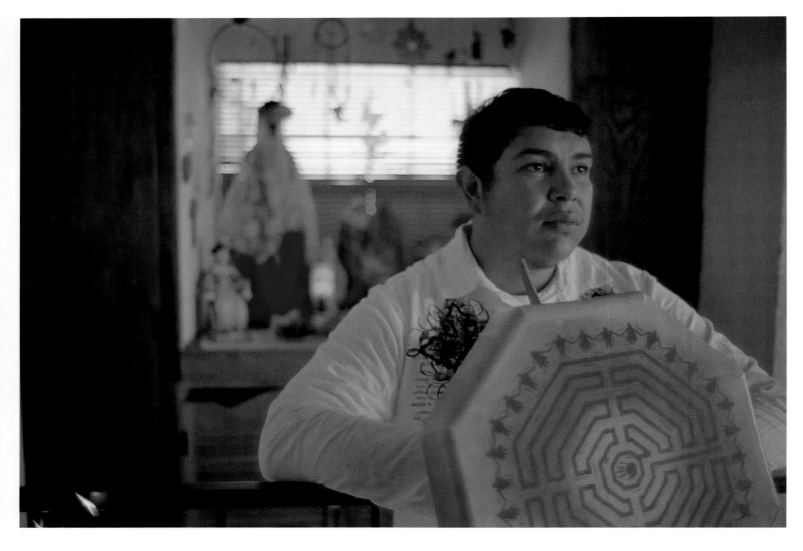

After studying inditas in class, one of my students told me that his family was from Ranchos de Taos and that they were Comanche. He then explained how, as a gift to the Holy Child, he and his family perform Comanche dances every New Year's Day at the homes of people whose names are derived in some form from Emmanuel, such as Manuel or Manuelita. The dances and songs were taught to him by his father, whose father in turn had taught him. In fact, the grandfather was known affectionately as El Comanche by many in the Taos area. They had been dancing for generations, singing many different songs and performing many different dances. As Genízaros, they grew up with these Comanche traditions; yet it has not always been easy to stay true to their identity.

Genízaros have always had a complex history in New Mexico. They could be too Indian for the Spanish and too Spanish for the Indians. In many cases, they were their own unique people who were often treated as outcasts by both groups. Unfortunately, things had not changed for my student, as he experienced this as well. On one occasion, he had gone to the office that works with American Indian students at my university to seek help with financial aid. He wanted to see if there were any scholarships for which he qualified. The administrative head of that office asked him about his tribal affiliation. He stated that he was a Genízaro and that his family had a

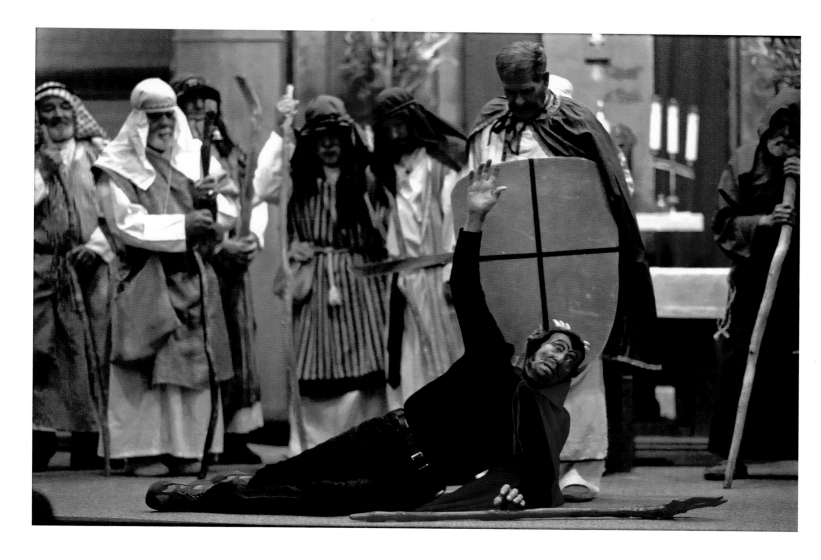

long-standing tradition of performing Comanche songs and dances. The administrator replied, "Oh, so you play Indian." My student left feeling dejected, suffering the same shame that thousands of other Genízaros must have felt for being part of a tradition of captives, slaves, and outcasts.

But this did not deter my student from being proud of who he was. He asked me if I could help him organize a presentation in which he and his family would perform some of their dances on campus. It was something he wanted to do before he graduated, as a parting gift to the university. I spoke with the same administrator and one of his colleagues, who were both from northern New Mexico Pueblos. We had a lengthy and confrontational discussion. They did not want students to see the Comanche dancers and think that is what Indians look like. As they told me, the Pueblos weren't powwow Indians, like the Genízaros and other Plains Indians. In their words, the Pueblo people don't dance for show and pageantry; they dance for ceremonial tradition. The second man was not even a full-blooded Indian, maybe half-blood, and he had the audacity to insinuate that my student was just a wannabe Indian. They both tried to veil their feelings behind the need to protect the image of American Indians, particularly the Pueblo people. But in truth, they did not want anything to do with these Genízaros, or so-called Indians.

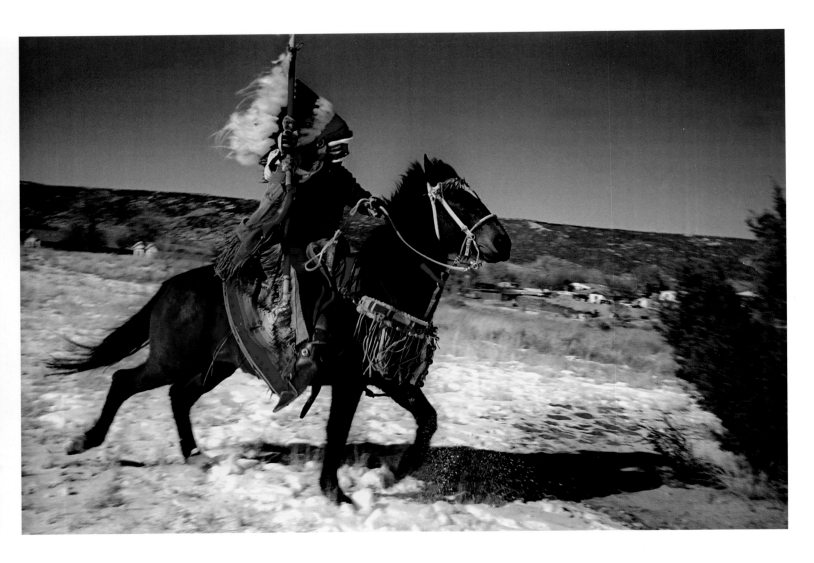

Despite the lack of support, we hosted our event, albeit off campus. Los Indígenes de Nuestra Señora de Guadalupe, also known as Tortugas Pueblo, invited us to have the symposium at their Casa del Pueblo in Mesilla Park. Also being Hispanicized Indians, but of mixed Piro, Manso, and Tiwa descent, they empathized with my student's situation and wanted to help. The symposium incorporated dancing and a panel of experts, including the Comanche leader and organizer LaDonna Harris, who shared with us that both of her grandfathers, one Hispanic and the other Indian, had been captives. However, in the Comanche tradition, they were integrated into the culture.

The symposium turned out to be a wonderful display of community that represented New Mexico at its finest. Members of both Tortugas and Los Comanches danced. Nobody could tell either group that they were not Indian. They both knew their history and traditions, in all their complexities. To my surprise, the American Indian administrator who offended my student and denied us support attended the symposium. He told me that his father knew the patriarch of the family, El Comanche, and that his father said he should support the Comanche dancers. They are who they said they were. They're people who were captured, enslaved, and eventually brought into the fold. Our unexpected guest even danced.

In the past, the Comanches took *cautivos*. These Comanche Genízaros continue to capture our hearts today. Their tradition of acceptance and regeneration lives on every New Year's Day. Their dances and songs speak of love, forgiveness, and mestizaje. They sing the spirit of Nuevo México:

> Oh yes, I love you honey
> Ya he ya he yo
> I don't care if you
> marry sixteen times again
> Oh yes, I love you honey
> Ya he ya he yo

I have only been in New Mexico for a little over a decade now. For many native New Mexicans, your family must date back to at least prestatehood to be considered New Mexican, and for *los manitos del norte*, to before the Treaty of Guadalupe Hidalgo. So for now I'm still a Tejano, which is fine by me. But like many New Mexicans, my obsession with the rain has increased over the years. Every time I pass the Rio Grande I take a quick scan and begin to worry about drought. But when the summer rain finally arrives, oh how refreshing it is! There's nothing quite like the smell of rain-drenched chaparral. I imagine it smelling as sweet as a burnt offering to God and no less holy. Rain, after all, is the biggest blessing to fall onto this land.

I originally came to New Mexico to study. But I always remember how my great-grandmother Simona told me before I left Houston that I was to meet my future wife someplace far from home. I knew the very first time I met Jessica that we were going to get married one day. A year later, in Old Town Albuquerque, I asked her to be my wife. At the gazebo in the plaza I knelt down on one knee and proposed. She said yes, and within minutes, from out of nowhere, it began to rain. We ran back to the car soaking wet, caught in a moment of surreal bliss. And the rain has been like a blessing to me ever since. *Gracias, Señor, por la lluvia y todas las bendiciones que vienen con ella.*

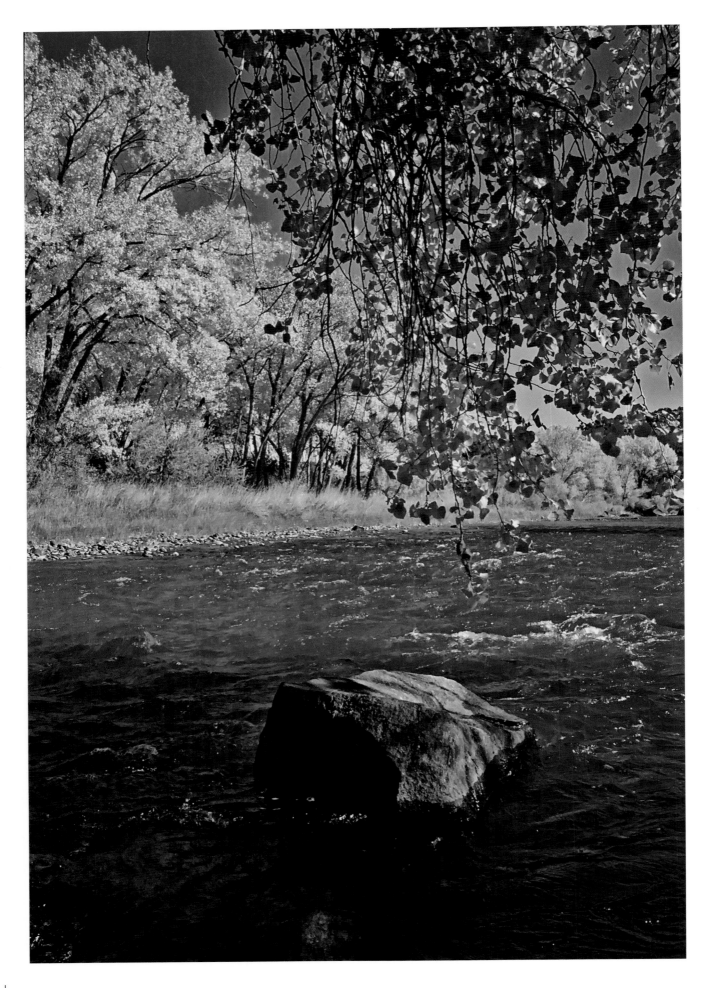

I Breathe the Cottonwood

I take the sagebrush scent in
The folding hills
The heat of the asphalt
Twenty-seven minutes past noon

Past the historic marker
And the twisted metal road sign
The yellow apple dotted orchards
The alfalfa

I take it all in

For you my brothers
And sisters
Lying on rubber mattresses
In your jail pods
Finger-nailing the names
Of your loved ones
On styrofoam cups

The cactus flower puckers
Its sweet magnolia lips
For you today
Its prickly arms stretching
Up toward the clouds and the sky

Las mesas, los arroyitos, los barrancos
El Río Grande
La urraca, el cuervo
The cigarette butt pinched
And yellowed, the crunched
Beer cans on the roadside

I take it all in

Past the presa and the remanse
The swimming hole
Where you frolicked in the water
With your first crush
Her hair wet and pasted
Against the slant of her forehead
Her bare shoulders glistening
con l'agua bendita

Throughout the valle
Las milpas de maíz
Are lined in processions
Their powdery tassels
Swaying back and forth
Like Pueblo feast day dancers
Atrás, adelante, atrás, adelante
Heya, heya, heya, ha

Past the ancient flat roofed houses
Like loaves of bread and their
Backyard hornos with their black
Toothless mouths yawning
The acequias' lazy gurgle
The tortolita's midafternoon murmur
The cleansing cota flower
Los chapulines, las chicharras
El garambullo, el capulín

For you, my brothers and sisters
The willow, the mud puddles
Reflecting brown the earth's skin

I take it all in

Un puño
de tierra

On a trip to south Texas, Ramón Ayala's version of "Un puño de tierra" played on the car radio. There's something special about cruising through mesquite country in the south Texas valley. The smell of saltwater from the gulf, the thick humidity that forces beads of sweat on your forehead, roadside fruit stands and barbecue vendors, and of course Tex-Mex music on the radio all contribute to its local identity. My senses are alive, and I am happy to be home.

As I listen to the music, I wonder how a song about death could be such a great tune for singing and dancing. After visiting an old cemetery near the Don Pedrito Jaramillo shrine in Los Olmos, the lyrics seemed to resonate even more strongly. Perhaps its message was one reason why people loved it so much. When we dance to a good song, sing with our compadres, or belt out a grito we feel alive. Because with the passing of a loved one we are reminded that our lives are limited and that the day we die we take nothing with us.

My father, like many people, is afraid of death. After listening to his fears over my lifetime I have come to understand that it really was not death he feared, but life. For the finiteness of death is so dark and abstract that it can paralyze our will to live.

Once, when I was young, we drove by a cemetery and my father asked me how many people I thought were dead there. I quickly scanned the size of the grounds and number of plots and put forth my best guess. He responded by saying, "All of them. They're all dead." He then went on to say how cemeteries are the richest places in the world because also buried there are the dreams and ideas of the deceased, which they either lacked the courage to pursue or the determination to complete. Or perhaps it was not a question of boldness or perseverance, but of timing. Maybe they just ran out of time. *Cuando te toca, te toca.*

Everybody wants to go to heaven, but nobody wants to die. When it's time, it's time. And that is life son, that's life. Everything dies.

—Lupe F. Herrera

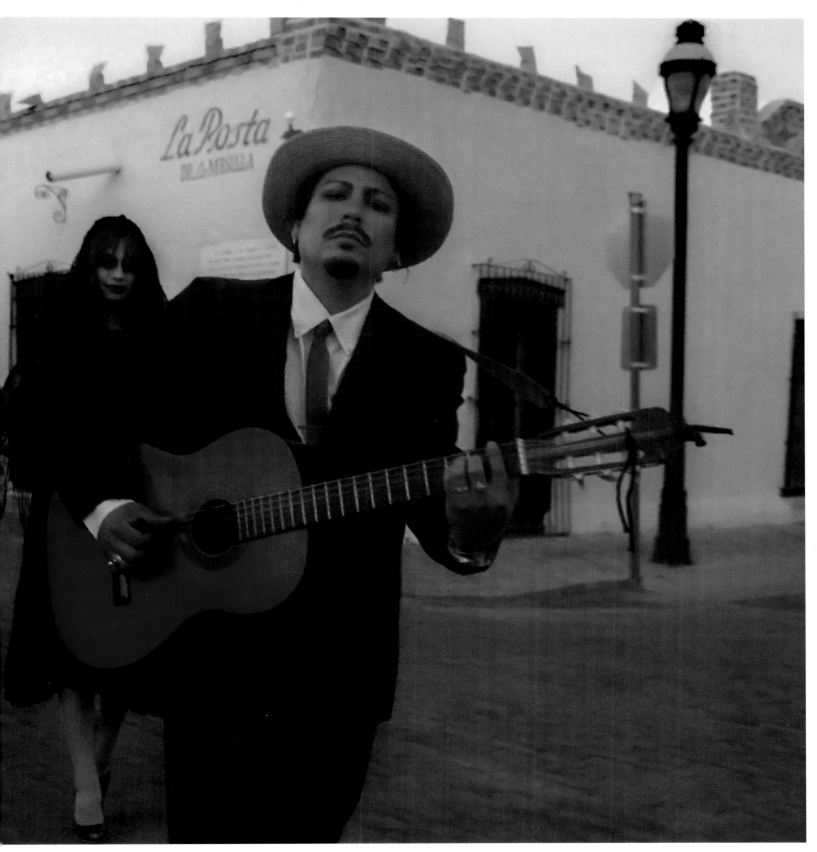

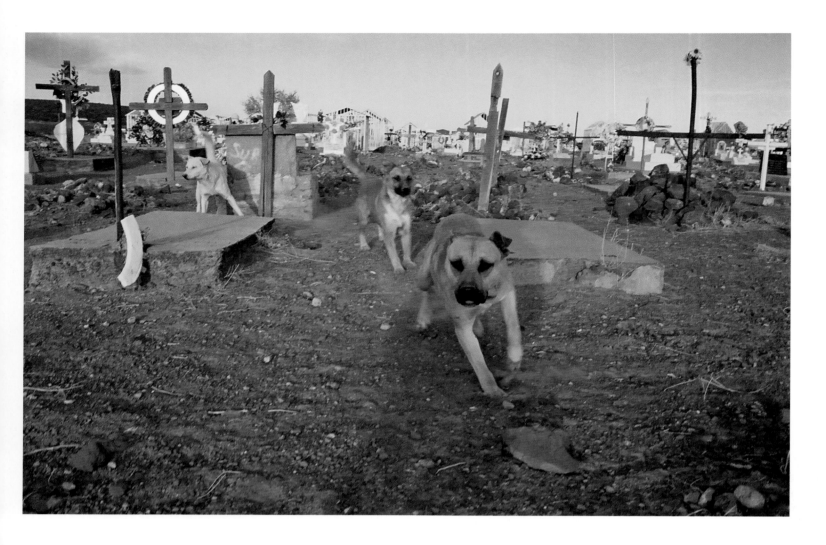

Most of us will not die peacefully in our sleep after living a full, abundant life. Many people die prematurely from sickness, accidents, or violent acts. Some die from cancer, heart disease, diabetes, or other illnesses. Some die after drinking and driving. Others are victims of those same people. Some lose a life-long battle with drugs. Some are murdered in vengeance or a jealous rage. And some people just die. Life can be beautiful, but it can also be painful. Though we are merely made of dust, the memories linger, sometimes for generations.

My father may be too pessimistic sometimes, or too Mexican, depending on how one sees it. But two things are for sure: he loves cantina music, and he's a hell of a dancer. As for those buried in the cemetery, he was right, they were all dead. But we'll never know how many of them really lived. *Por eso hay que darle gusto al gusto*, as the song says. It's true, we can't take anything with us, but we can sure leave many memories behind for the rest to treasure and pass on.

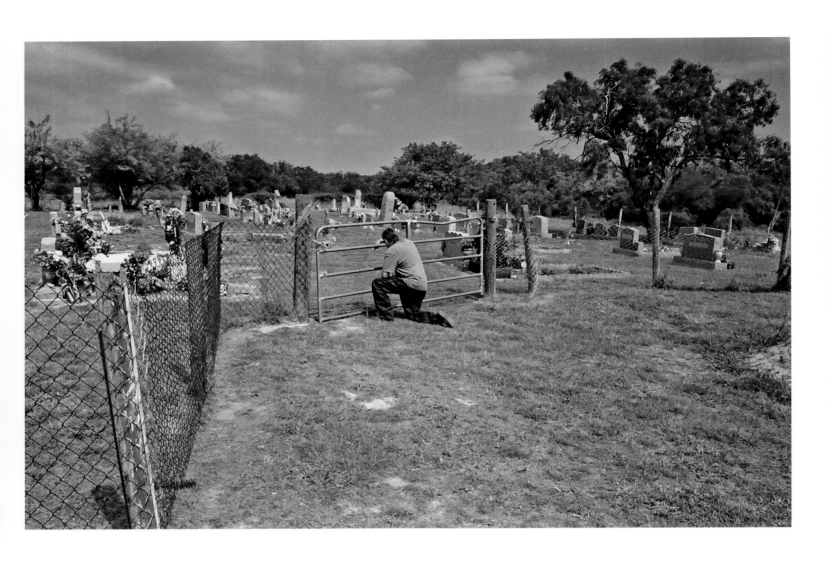

While studying abroad in Mexico City I received the news that my Uncle Ricky, my dad's older brother, had been shot and killed at his home. He was forty-nine years old. It was a tragic event for my family, but especially for my dad, who lost his only full brother and his best friend.

The crime scene told it all. At his home a stolen car was found with three doors left open. A separate getaway car must have been waiting nearby. My uncle had just returned from a night out with my dad. As he drove up to his house, he saw a car approach him. He must have known that someone was after him. He ran for the front door, grabbed his shotgun just inside the doorway, and before he turned around was shot in the back several times. He was able to get off one shot that hit the top of the door jamb. The police never arrested any suspects.

My father misses his brother dearly. Out of habit, for months afterward he would call him to tell him a joke or story. Other times he would wake up in the middle of the night and cry out his name—Richard—thinking he was there. Some days, and always on the anniversary of his death, he visits his brother's plot at the Veteran's National Cemetery in Houston to sit and talk with him. My father's pain is deep and inconsolable, but bearable enough for him to keep living himself.

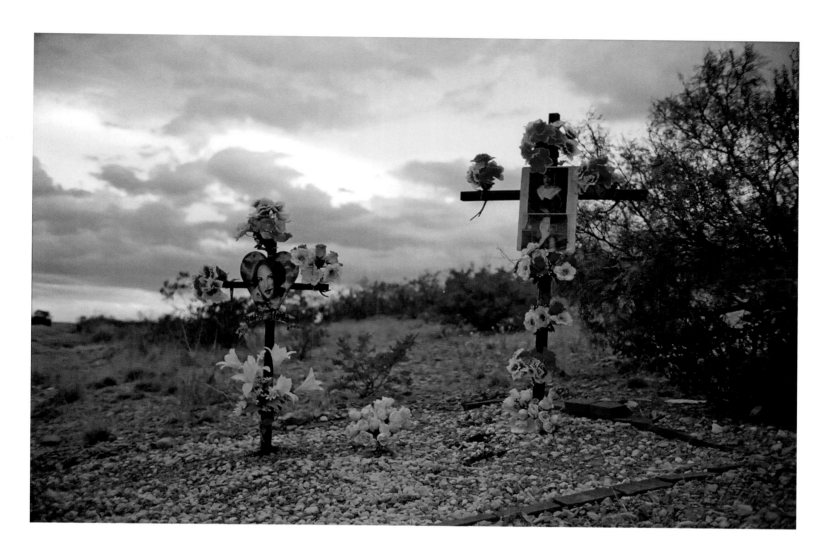

Today when I ask my father about death he confesses that he thinks about it constantly. He tells me that death can come in many forms, like in the case of his half brother, Nicky, whose love is dead for us, my father says, after a fallout that was never healed. He recalls a fellow soldier in Vietnam whom they called Puppet because he was strangled to death when his parachute got tangled in the trees. He talks about how his friend's son recently committed suicide after his mother died of cancer. My father's friend died soon after he lost his wife and son; at the wake the daughter said that her dad had died of a broken heart. In a matter-of-fact way my father says that it was just their time. Some people leave us too early and without good reason, and that's just the way it is. But God, how we miss them.

A mis familiares fallecidos, we remember you with love and tenderness . . .

We remember Ricarda Mejía, my maternal great-grandmother, whose death was a mystery and family secret.

We remember Simona Galaviz Murphy, my paternal great-grandmother, who died at the ripe old age of ninety-six.

We remember Aurora Cepeda, my paternal grandmother, who died before her mother, Simona, of an aneurism.

We remember Consuelo Mejía Salazar, my maternal grandmother, whose life was our blessing.

We remember Lino Salazar, my maternal grandfather, who was born Agustín Caffarel but changed his name upon immigrating to this country, and who died of a hard life.

We remember Alfredo "Fito" Treviño Sáenz, my cousins' tío and an old-school pachuco, who died of diabetes complications.

We remember Richard Ramírez, my uncle, who died from gunshot wounds.

We remember Rubén Rodríguez, my cousin, who died at the age of thirty-six of stomach cancer.

Que en paz descansen. Nunca los olvidaremos . . .

Years after my father died

and his body was lain into the earth
his garden continued to yield vegetables
radishes and carrots burrowed into the dark
moist dirt and the onion stalks stood straight
as the soldiers standing for the twenty-one gun salute

yesterday morning crickets purred
under the shade of the last broad
green leafed plant in the yard
while insects flicked under a canopy
of morning glories

last time I saw you
we spoke of conflict
and that all endings
must have resolution

this afternoon I long
for the voice of the
red breasted robin

I yearn for the slow sinking rhythm
of a long summer evening
and warm conversation

a thin thread of web glistens
in the crook of the plum tree
I am accompanied only
by the caw and swooping flight
of the crow across the afternoon sky

the sunflowers in the meadow
are crowned with halos of petals
browned and golden in the haze
of autumn sunlight

crouched and looking
like old men
with wrinkled faces

their reach toward the sun

frozen in a final grasp
toward warmth and light

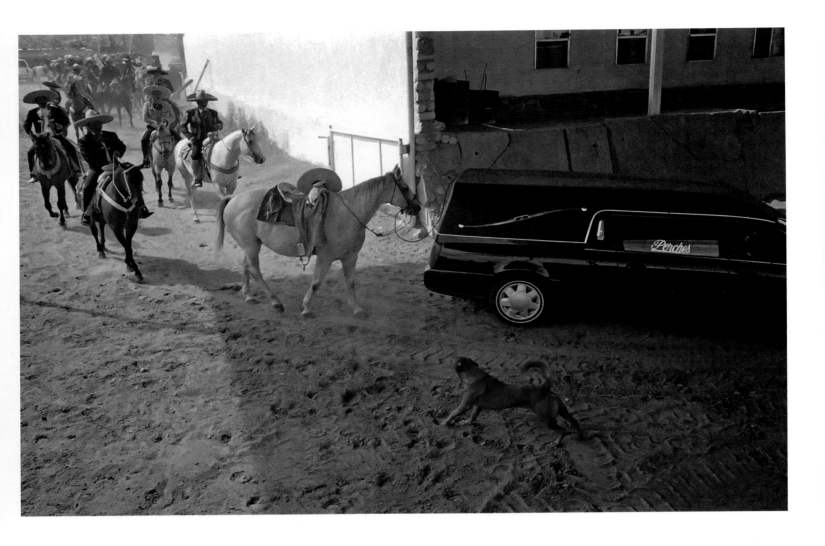

Father Martín Cordero called me on a Tuesday morning to tell me that Don Omar Castro, the patriarch of the Castro family and founder of the Lienzo Charro Los Castro in Canutillo, New Mexico, had passed away and that his funeral service would be held in a few hours. It was to be a *charreada* funeral for the man who had brought México's national sport to southern New Mexico.

Over the past two years we had been to a handful of charreadas in Vado, New Mexico. It was a beautiful tradition of horsemanship and community. The riding ability demonstrated by both men and women was amazing. Every event was defined by skill and precision. The rider and horse worked together to perform *suertes* that take years to learn and a lifetime to perfect. And although this is a Mexican pastime, in southern New Mexico it had become a part of the American landscape, both culturally and physically.

The first charreada we attended in Vado was a clear example of how Mexican tradition had become a part of the local community. The announcer, also dressed in his *charro* suit, stood among the audience members and spoke eloquent Spanish, entertaining the crowd with a verbal agility equal to

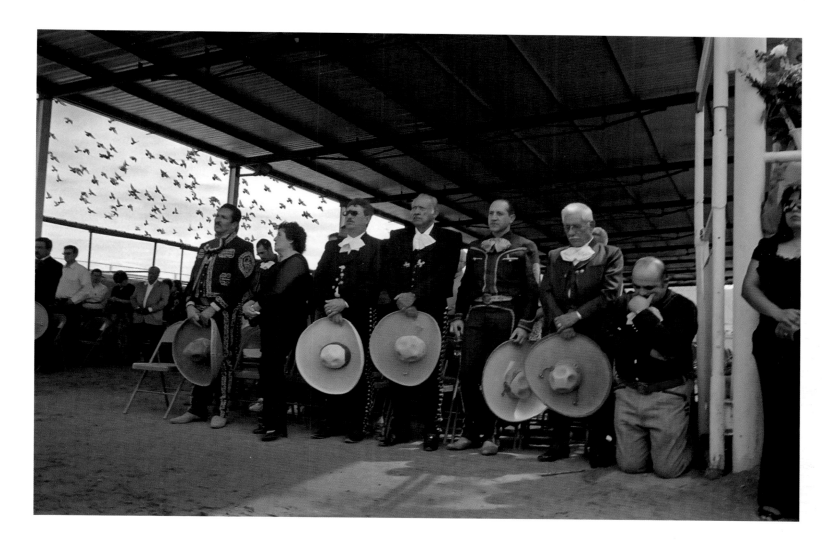

that of the high level of charro horsemanship. His role was
also that of teacher, educating the crowd about the charrería,
its traditions, its history, the details behind each event, and
how they are scored. As the *escaramuza*, the female riding
team, carried the flags into the arena, the announcer was clear
to explain that in the charrería participants salute both the
Mexican and American flags. They honor México because
that was the country *que nos vio nacer.* And they honor the
U.S. flag because it is the country that welcomed us and that
we now call home.

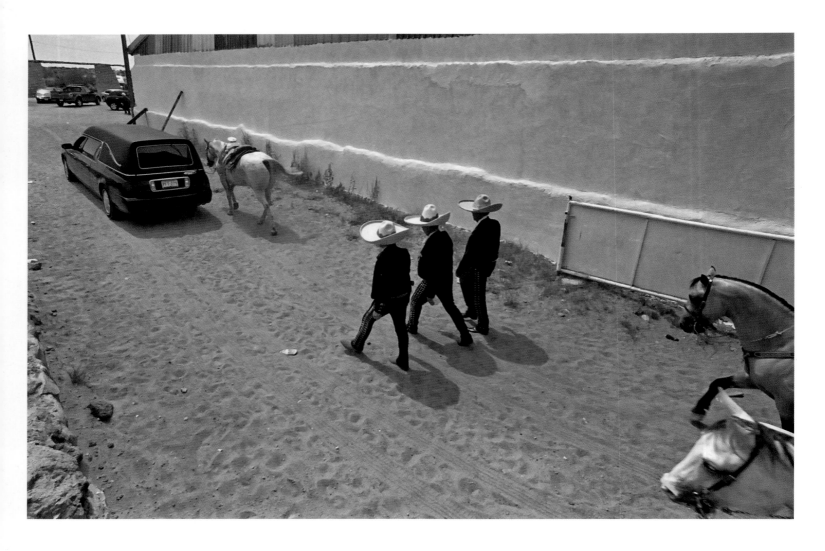

After several visits to the charreada it was clear this was a close-knit community that involved the entire family as part of its tradition. Despite knowing this, I was still taken back when I saw Don Omar's charreada funeral procession. Charros and their families came from Arizona, New Mexico, Texas, and Chihuahua to honor Don Omar with a proper charro funeral. Men of all ages were dressed in their best *trajes de charro*. They saddled their horses with full regalia. Every man mounted his horse, ready to enter the arena. But one horse remained unmounted; Don Omar's horse rode alone.

With Don Omar's horse tied to the back, the hearse slowly made its way into the arena. The charros formed two rows, and with their hats held high they saluted the horse with an empty saddle. I had never seen a horse seem so sad, but it was clear that animals could mourn a loss. His eyes were large and glossy, his head and neck hung low, and his back seemed to carry a weight that was not there. Even Don Omar's dog loyally followed in tow.

Men who were usually stoic shed tears and gave each other big, long hugs with strong pats on the back. Just a few months ago they had been in the arena passing around a bottle of tequila, celebrating the birthday of Miguel, Don Omar's son.

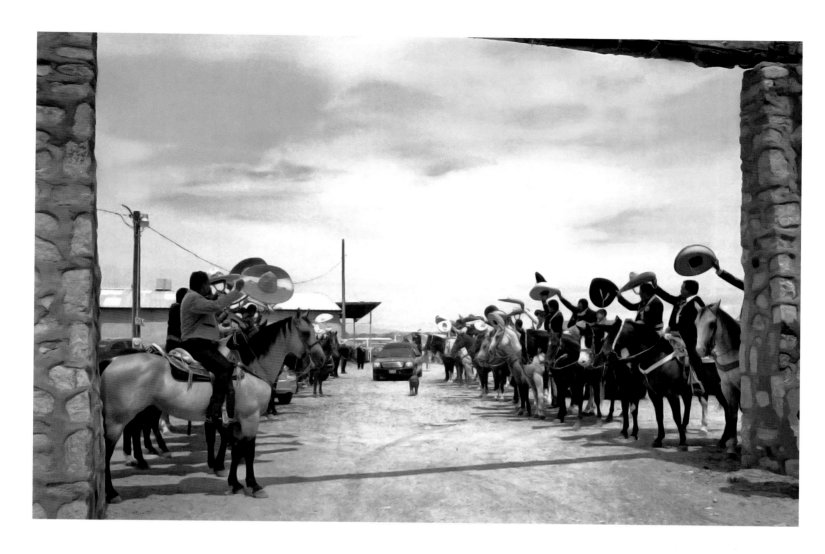

From one year to the next, both life and the charreada completed its seasons. A great charro had passed way, but he had built a place where his memory will always live. Soon enough in the months to come the charros and their horses would once again be kicking up dirt at the Lienzo Castro. Don Omar's legacy and the charreada in southern New Mexico live on, even amid the dust.

Throughout our travels we have been blessed more by pure happenstance than by good planning. While en route to San Antonio we were hoping to meet with Sandra Cisneros, but we knew that she had just returned from a speaking engagement and would soon be departing for another. Her assistant, Bill Sanchez, was instrumental in helping arrange a time when we could stop by her house to visit. But the coordination of our trip and her schedule was less than ideal.

While driving through Falfurrias in south Texas we noticed a sign pointing in the direction of the shrine and resting place of the famous curandero Don Pedrito Jaramillo. It was a detour we were compelled to take. The small building that housed the shrine to this miraculous faith healer was full of photos and letters hanging on every wall. The *testimonios* thanked him for curing illnesses, helping in dire circumstances, and providing relief to the needy. It was ironic that we had just arrived at this sacred place of heartfelt petitions when Sandra called and invited us to meet at her home that afternoon.

She later told us that she had visited this very shrine after a period of creative struggle to write her book *Woman Hollering Creek.* Upon reading the letters posted inside the shrine, she realized that she did not have to write stories on behalf of others; she just needed to let them speak for themselves. As a result, she was able to create the vignette "Little Miracles, Kept Promises," a testament to the power of faith and prayer.

An hour after leaving the shrine, we arrived at the town of Three Rivers. History again tugged at our subconscious minds: we had to stop. In 1948 the remains of Private Felix Longoria were recovered from the Philippines, where he was killed in action during World War II. Despite his service to his country, the only funeral home in Three Rivers, which was Anglo owned, refused to provide funeral services for him because he was "Mexican." The widow and family of Felix Longoria did not request special arrangements or set out to memorialize him as a martyr for civil rights. They just wanted to honor his patriotic sacrifice by giving him one of the most basic of human rights—a dignified burial. The outlandish discriminatory act led Dr. Héctor Pérez García, the founder of the American G.I. Forum and a World War II army doctor, to take action. With the aid of then–Texas Senator Lyndon B. Johnson, Private Longoria was buried with full military honors at Arlington National Cemetery.

We located the defunct funeral home; the only thing that pointed to the dilapidated, vacant building as a site of public interest was the Texas historical marker planted on the front lawn. As we peered through the dirt-stained windows and saw the cobwebs, boxes of discarded old records, and look of hasty abandonment, it was clear that not even death cared to visit anymore. The years of embalmment-soaked air could not prevent this funeral home from decaying. Nonetheless, its story played an important part in the American struggle for equal rights. For although this place was not sacred, the dignity of an almost forgotten soldier was. Like the mourners who place a descanso along the road to honor the preciousness of lives lost, or the faithful who pin *peticiones* and testimonios inside the shrines they visit, we have marked our memories with words and images to commemorate our journey.

Descanso

i come down into the valley
sunflowers and wild floral patterns
on the meadows

the mountain's cleft
in the distance behind your
final resting place

strong, stubborn, like you

and the light does
fall here in the evening
gentle and soothing
in the morning, too

through that week
of burial arrangements
i sat on your porch
and solemnly wondered

anger and memories
and questions crisscrossing

what were you thinking
feeling?
how could it've come to this?

the valley out beyond
barren and numb

and, oh, those trains
how they rolled slowly past

their sound still haunts me

from the west unto the east
from the east unto the west

but now
the sparrows
the alfalfa flower
blue, violet, yellow

butterflies, so many, so many
and all around your *descanso*
like a blanket of sunrise

daisies

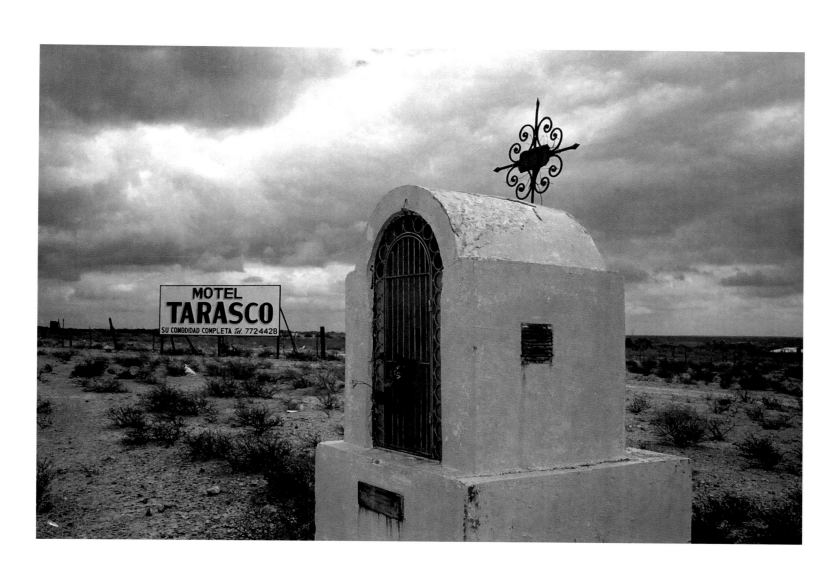

As It Will Be Without Him

Her life will not go on
As it was with him
But it will go on
As it will be
Without him

The rosary service is on an early Saturday morning at the *morada*.
The family has requested the prayers of the *hermanos* and *hermanas*,
because they need an early Mass and the church will not open its doors before 10 a.m.

Death, as untimely as it is,
has arrived.
It came at 11:15 p.m. on the twenty-sixth of December.
It did not wait for the New Year to unravel itself from the gift wrappings
nor for the nativity lights to be unstrung and stored away for next year.

His was a life of illness these last years. Still, the friendships remained. "Come on over,
everyone's here, it's like a reunion!" His voice trailed out of the phone, calling his wife
from a matanza only a week before.

The bikers in black leather and black jeans, scarves around their necks, their faces peering out of
wraparound sunglasses, stand outside in the churchyard. "Mira, el Smiley. How you been, bro'?
Long time no see." The young ones in their broken Spanish greet the elders,
"Buenos días. ¿Cómo 'stán?"

Life will not go on
As it was with him
But it will go on
As it will be
Without him

Cuando lleguemos

Near the small town of Zaragoza, Coahuila, an hour south of the border from Eagle Pass, Texas, sits a two-room house made of cement and chicken wire. Next to the house runs a spring-fed acequia with clear water that bleeds into a thick mangrove marsh. Large, shady cypress trees grow along the acequia's banks, and an open field with tall grass blankets the area around the house. The house was built by Leocadio Sánchez Beltrán and María del Socorro García Sánchez in the early twentieth century. The house has been home to many since.

Every Fourth of July, the descendents of the Sánchez-García family travel to Zaragoza for their family reunion. They come from Chicago, Florida, California, New Mexico, Texas, and several places in between. The grandchildren and great-grandchildren, now with adult children of their own, remember the Zaragoza of their childhood. They remember how that same acequia fed several smaller ones that ran behind the houses, which provided water before there was plumbing. They remember how the men would caravan on horseback in a *cabalgata*, a tradition from the days when the charros would serve as a de facto national guard. They remember the little ranch house where a newlywed couple or a family in need would stay from several months up to a year, until they got on their feet. Their stories all begin with "*Te acuerdas cuando . . . ,*" remember when, and end with another story about another time or person. The stories keep going late into the night and end with whispers of memories blending into dreams. Here, together at this small ranch, it all starts to come back to them, *este y esta, aquel y el otro*, until they piece it all back together, story by story, person by person, memory by memory.

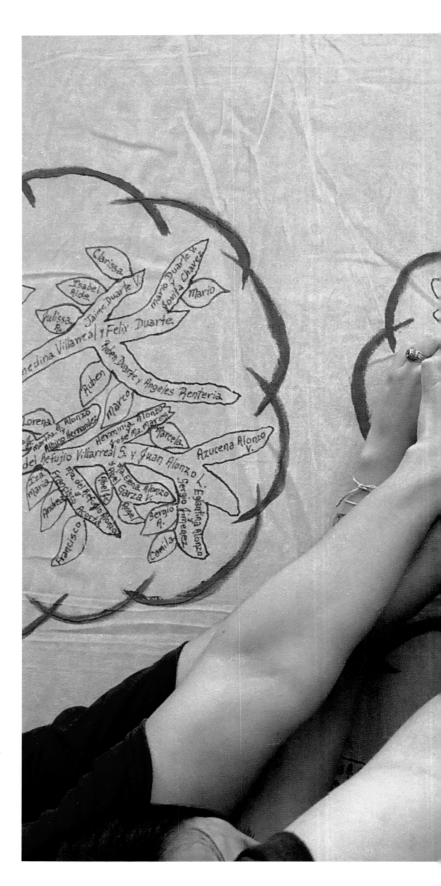

Go back to Mexico!

 —Confrontational stranger

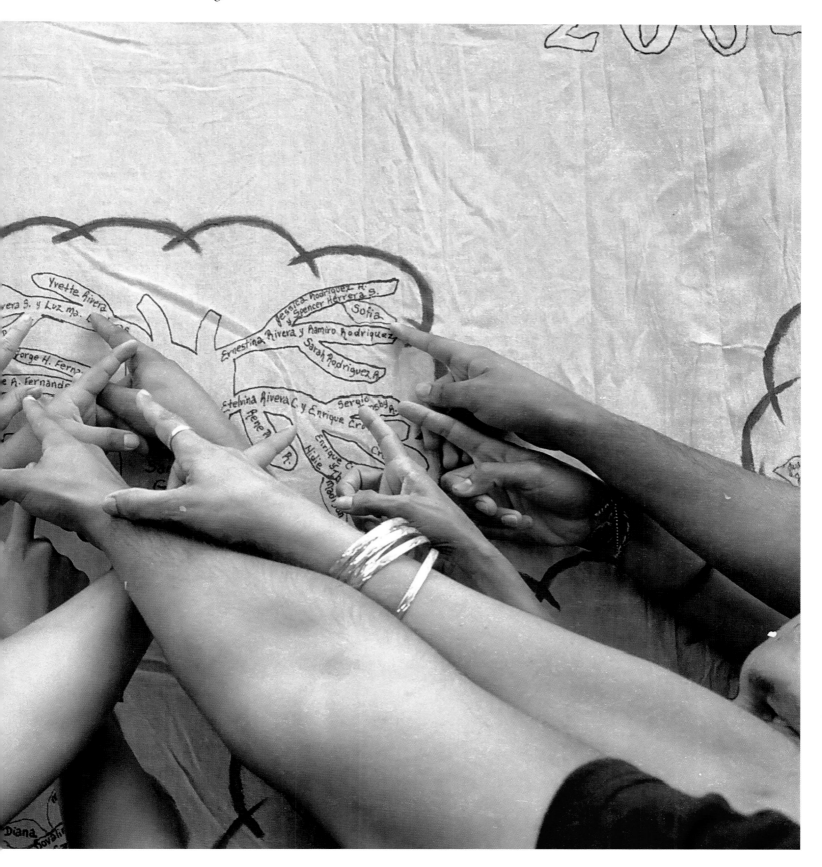

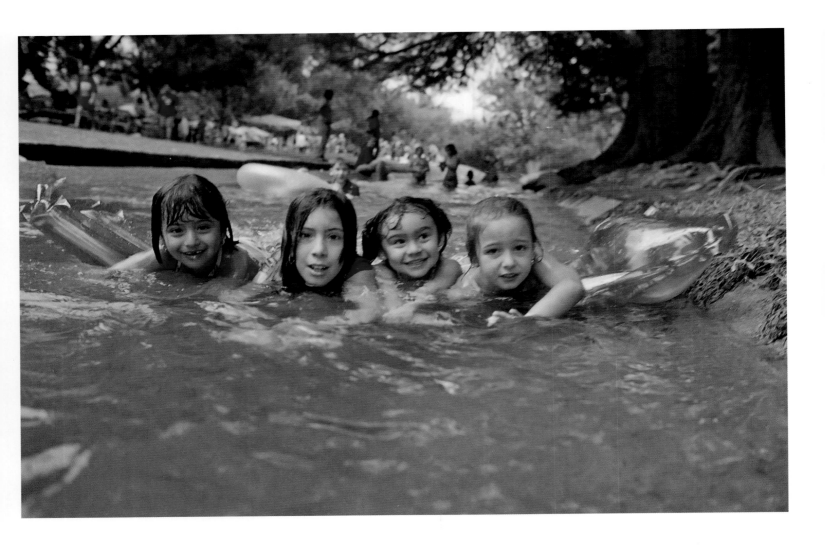

It's ironic that the people and their stories reunite in México during the American Fourth of July holiday to celebrate their Mexican heritage and reconnect with their extended family. They hug, laugh, eat, drink, sing, dance, and remember. *Aquí la familia es sagrada, y la memoria de ella, aún más.*

A large tarp with a hand-painted drawing of the family tree hangs against the wall of the house. The roots, trunk, and branches spread across the tarp, with names marking the tree's branches. I see my wife's name and mine next to hers. From our branch on the family tree, a small leaf has sprung. On the leaf it reads "Sofía," the name of our first daughter. I feel a sense of pride knowing that my daughter has roots she can trace back to México. She does not yet appreciate it, but we have arrived at a place that has been a journey across generations.

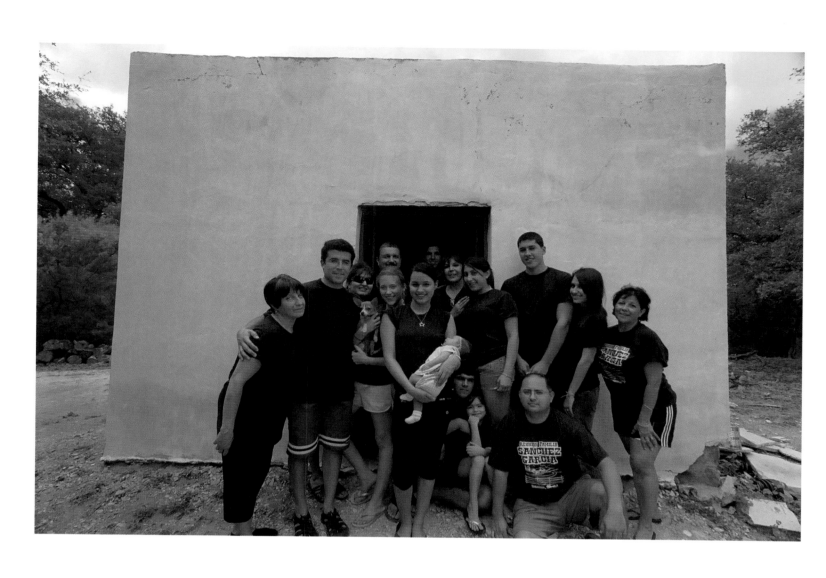

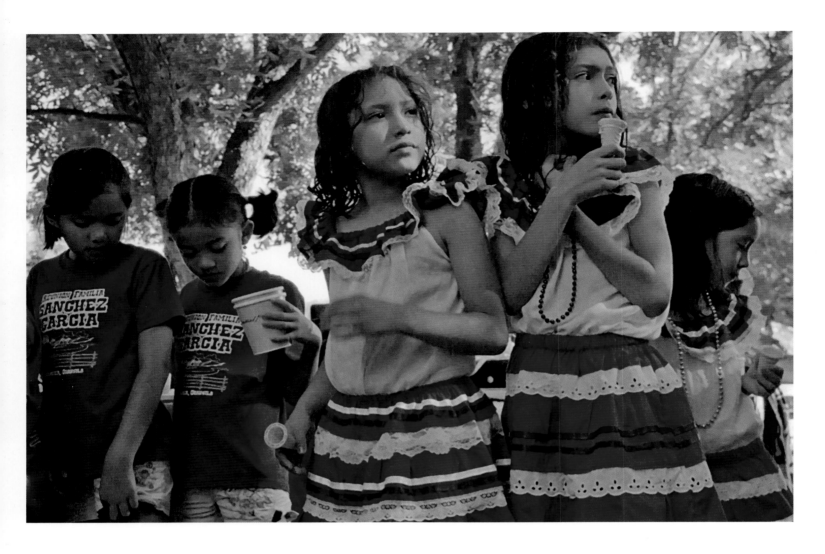

In the 1971 Chicano classic . . . *Y no se lo tragó la tierra*, Tomás Rivera describes a community of working-class Mexican Americans who live day to day, picking crops in Texas and throughout the Midwest. To cope with their lack of social mobility, they dream of a better life in which they will not suffer the injustices of poverty and racism. The book's vignette "Cuando lleguemos" portrays their struggles and how different characters plan for a better future. One man, tired of being shuttled like cattle in the backs of trucks, anxiously awaits the next onion harvest so he can earn enough money to buy his own car. Another man talks about how during his next trip to Minnesota, he will search for a better, more stable job and settle down instead of following the backbreaking seasonal work of crop picking. Others just hope to stay in one place long enough so they can send their children to school and break the cycle of poverty. Rivera's quintessential text about Chicano migrant workers during the 1940s and '50s documents several themes of the Chicano struggle during those years. However, the idea behind the vignette's title "Cuando lleguemos" ("When We Arrive") is ironic because in truth this group of Chicano migrant workers never arrives at their imagined destination. It is almost impossible to finally arrive when you're always arriving.

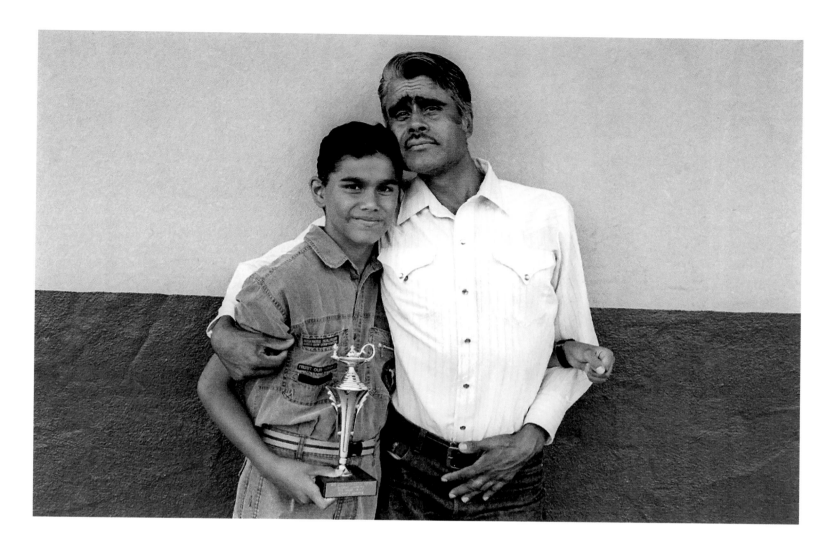

Originally written in Spanish, Rivera's masterful narrative was translated into English and has been heavily read in the translated language. Lost in translation is that the chapter title "Cuando lleguemos" has different meanings in the two languages. In English, the notion of "when we arrive" is simply a matter of time. In Spanish, however, when referring to an undefined future event, one must use the subjunctive tense, a grammatical structure that has, for the most part, lost its use in English. Therefore, the word *lleguemos* does not strictly imply "when we arrive." It is ambiguous because it leaves open the possibility that we may never arrive, and Rivera's characters understand this. During the 1940s and '50s this was certainly the mindset of many Mexican and Chicano families who had little recourse but to migrate to find work, always living in the moment, moving from crop to crop, surviving day to day. A few fortunate ones found their way. Yet many of them never quite arrived at their planned destinations.

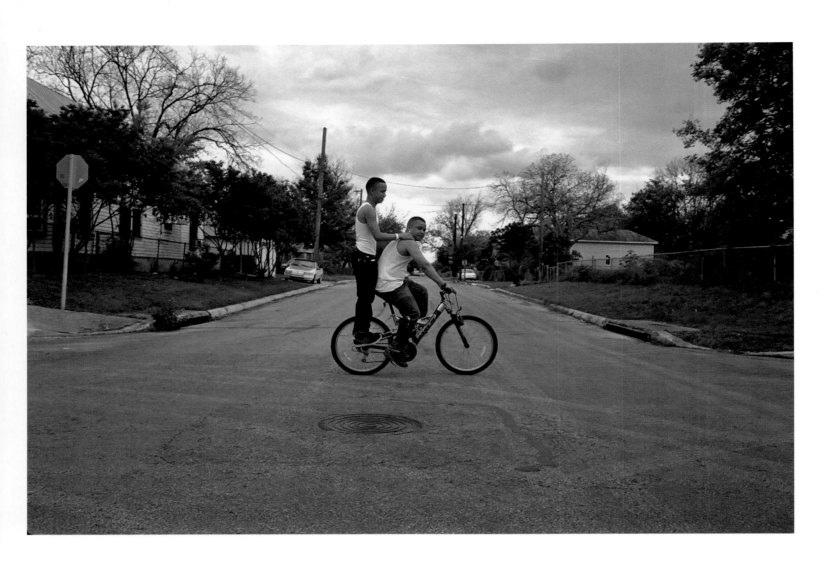

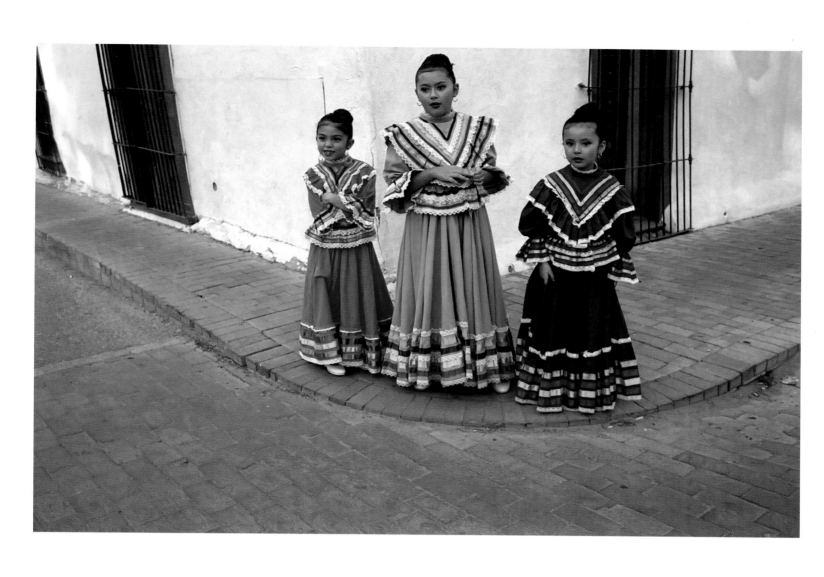

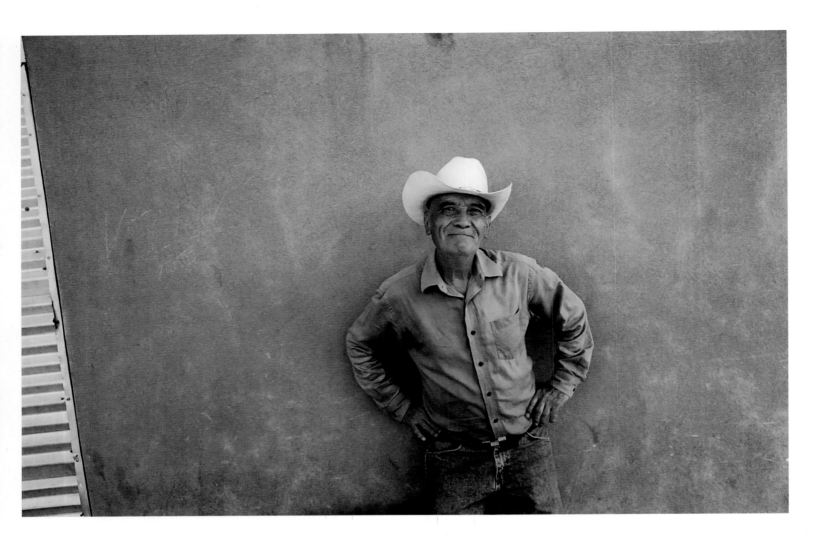

As I think about arrival and return and all of the connotations that are tied to *Sagrado*, I am reminded of the marquee that sits in front of the Old Town Restaurant on Valley Drive in Las Cruces, New Mexico, the city where this project began. Numerous messages have surely greeted many passersby over the years. But its core message and menu have remained mostly unchanged; the restaurant is still serving up Mexican combo plates, and the marquee continues to read, "All you can eat menudo on Sundays" on one side and "Lléguele" on the other. *¿Cuándo vamos a llegar? Pues, la verdad es que nunca nos hemos ido. Pero para los que andan en camino, lléguele, aquí los estamos esperando.*

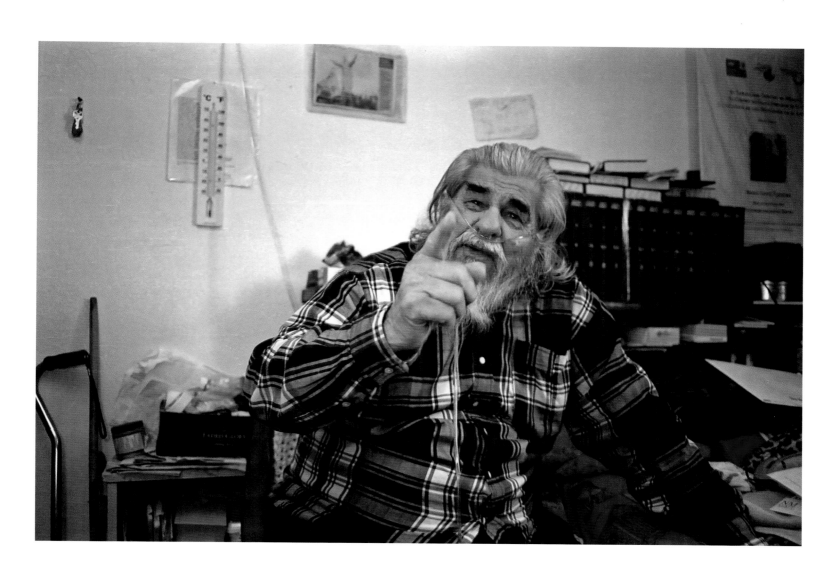

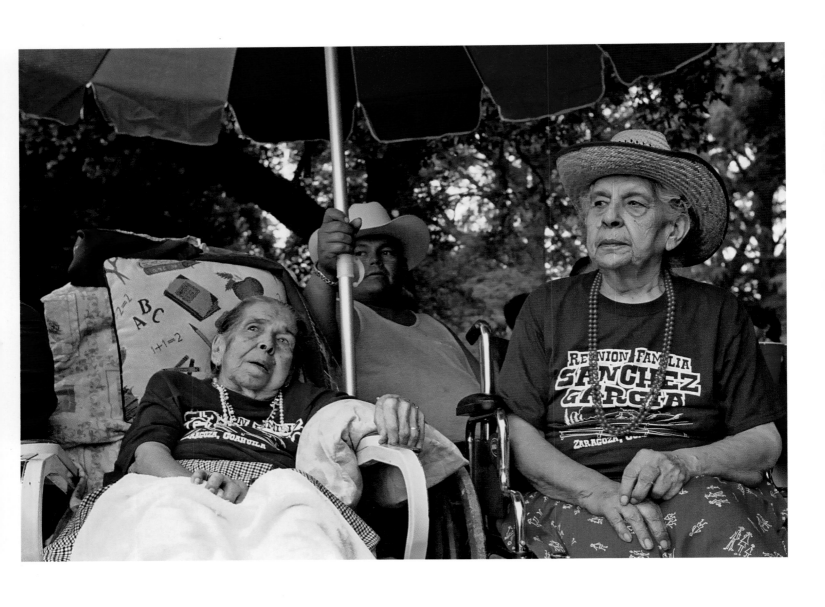

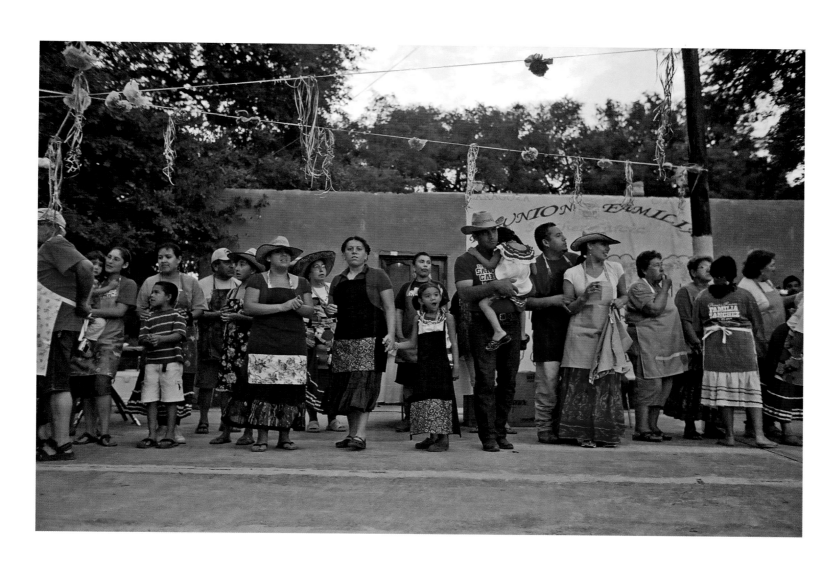

Para todos los paisas:
el que nace
pa resolanero
dondequiera
hace resolana

Botes de diez

nos quitamos los sombreros
en saludo de aquellos
que detienen abiertas
las puertas de la locura

dejando entrar y salir
al según vamos trompezando
por el camino chueco
de la vida negra

negra pero alumbrada
con cariños y apoyos
de familiares, amigos
y estranjeros

solamente la mano de Dios podrá separarnos

¿y qué fuera
sin la carría de los babos'
que nos mueve como chicotasos
a que síganos con la carrera?

carreras laboriosas
que si bien atendidas
al fin disfrutan su jardín
y acarician corazones
con alegría

como las notas
que soplavan de la musiquita
de Don Silviares
en tiempos antepasados
cuando él andava
por los valles
sur de Colorado
vendiendo chile
en carro de caballo

y especialmente para Tomás y David

que los miro venir
todo el caminito
rascuaches y doblados
con sacos llenos
de cuentos calientitos

pa' desarrollar
por los pueblitos
en estos tiempos
tan fríos y deslumbrados

aquí ando yo
como culebra jardinera
cuidando la milpita
de memorias

y les dejo
una cosechita
de unas cuantas
palabras empolvadas

y en la manera
de los fruteros
del barrio de los malditos
me despido diciéndoles

*hasta las
otras piscas,
plebe*

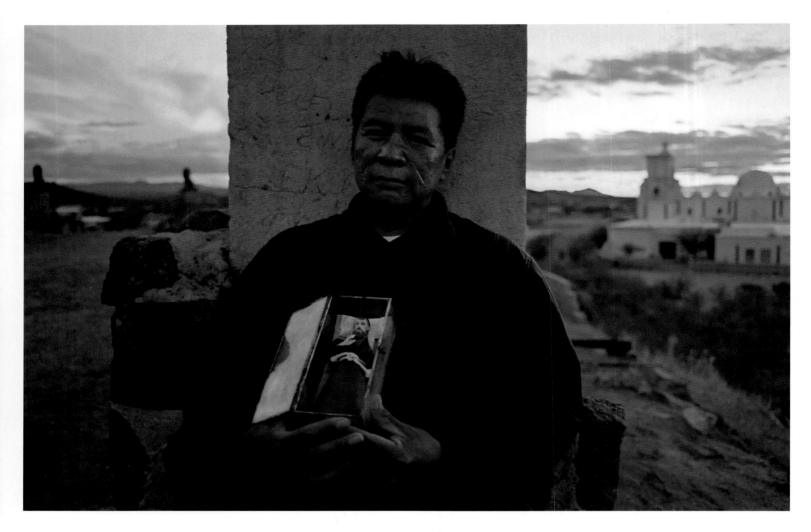

Si es tuyo, aunque te quites. Y si no,
aunque te pongas.

 —Velia Moreno

Epilogue

In Search of Pancho Villa

It was still dark outside when I went to kiss my wife good-bye. Half-asleep, she turned to me before I left the room and whispered, "I hope you find what you're looking for." Five years into this project, and that was the first time she had said that. What did she think I was looking for, I wondered. I wasn't quite sure myself. Somehow I knew it had to do with this elusive notion of culture and identity.

In 2010 we visited the historic Mission San Xavier del Bac in Tucson. Founded by Padre Eusebio Kino in 1692, the mission was built by a large workforce of Tohono O'odham between 1783 and 1797. It is a beautiful white stucco building known as the "White Dove of the Desert." You can see it from miles away. The mission lies in the heart of the Native American Southwest. Tohono O'odham, Apache, and Pascua Yaqui have lived in the Sonoran Desert for centuries. Next to the mission sits Grotto Hill, with a large cross at the top. A circular path surrounds the hill, where people pray and light candles.

As I walked around Grotto Hill I noticed an Indian man standing alone along the exterior rock wall. Talking to himself in a low, hushed tone, he had an anxious look about him. I left and returned to the church. As the light of the day began to wane, I found Levi back at the grotto, talking with the same man. I was reminded of how good poets find poetry in unlikely places. As Levi would say, "The last thing in poetry is the poem."

The man introduced himself, "My name is Carlos Luis, but they call me Pancho Villa." In some ways he represented the stereotypical image of the hard-luck Indian. He had recently been released from jail; homeless, he spent the night in a nearby field; and he started the morning by drinking. But once I began to hear his story, my short-sighted impression of him changed. As it turned out, it was our good fortune to meet him, because he had some important things to share with us.

Pancho Villa is a Pascua Yaqui. At a young age, he was given two options by a judge who oversaw his case in the juvenile court system: go to jail or join the army. He figured, what's the difference—he would get killed in either place—but at least in the army they'd give him a gun to defend himself. Pancho Villa became a member of the Screaming Eagles, the 101st Airborne Division. Years later, after leaving the army and after his stint in prison, he was broke, homeless, and alone. But he had two things going for him—a memory from his grandmother's home and his songs.

Pancho Villa told us that when he was a child, the priests would come to their home and take things in the name of the church. Behind his grandmother's stove was a hole in the wall where they would store precious belongings, hiding them from the priests and their unannounced raids. He remembered that his grandmother had kept a small *muñeco* of San Francisco de Asis behind the wall. He was released from prison just in time to retrieve the muñeco; the next day the house was to be bulldozed so that his sister could put up a mobile home. When he went to the house and stuck his hand behind the wall, there was the muñeco, in mint condition in a small glass case, just as his grandmother had left it.

The day we met Carlos, he had come to San Xavier to see if the priest might want to buy it. The priest asked if he would instead donate it to the church. He left mad after he quickly realized that all the church ever did was exploit the Indians. He then carefully pulled the muñeco out of his bag so we could see it. It was a beautiful piece of art. His grandmother was wise to hide it. I commented on how fortunate he was to have found it. He firmly corrected me and said that he had not found anything; it was already there.

———————

The hole in the wall, the muñeco, his childhood home that had been razed—so many memories ran through his head. All he had left were the clothes on his back and this porcelain saint. With no place to call home, no one to help him, and a run of hard luck, he seemed cursed. But then he shared his songs with us, which were his salvation and our blessing. He sang the Our Father in his native language while we held hands and he prayed for us. His songs were powerful reminders that healing comes in many forms. I suppose that is why he called them his medicine.

For two years afterward we talked about our encounter with Pancho Villa and wondered what had become of him. In January 2012 we were finally able to return to the place where we had met him. It was unlikely that he would be there, but we still held out hope. As I suspected, he was nowhere to be found. But the image of him remained imprinted in our collective memory. Holding the encased muñeco against his chest, the sun's last light fading away behind a small mountain chain, and a dusk-tinted Mission San Xavier del Bac in the background, the image of Pancho Villa still haunted us. The experience had been surreal; we even began to wonder if he really existed, or was he a dream? Just like his namesake, he became a legend who occupied our imaginations. But too many questions lingered. Who was Carlos Luis "Pancho Villa"? What became of him? Did he ever find peace in his life? Some things will always remain a mystery. But maybe one day, we'll come back again in search of Pancho Villa.

As for my wife's words, they resonated with me during our search for culture and community. Ever since my first trip to La Soledad and now after five-plus years into this project, had I finally found what I was looking for? It turns out it was just like Pancho Villa had said: you can only find what is lost. Sometimes what you're looking for has been there all along.

Pancho Villa's Prayers

My name is Carlos Luis
Nickname is Pancho Villa
I grew up with that name since I was eight years old

I am a Yaqui Pascua
My grandparents they come from Nogales

Mexico side

But they grew up over there in Grand Stone
Old Pascua

Now this song is the Lord's Prayer
And it goes like this

Jana yo . . . jana yo y na . . .
Our Father who art in heaven
Deliver us from the evil one
Jana yo y na, jana yo
O sana, Amen

These are the blessings of all the best songs
That the lord gave me
I don't know why he gave me these songs
But he gave them to me

And I share them with you

I sing the most powerful songs

May God bless you all, man

It's all I can do for you, brothers

I sing the most powerful songs
That I can for you

They're not witching songs
They're blessing songs

Notes on the Photographs

I like to wander in search of a photograph. The truth of an image lies on the fringes of life. Many of these images are made from such encounters: a little girl, happily swinging next to the border fence, or a stranger, asking me to take a picture of his pit bull.

The photographs in this book were made with Leica M6s, using a 35 mm lens. All images were recorded on Fuji Pro 400H professional color negative film.

At the start of this project, I realized I had the opportunity to show the border is not just a land of fences, drug cartels, and murders. The border is the human condition: peoples struggling to find their identity and place in the world.

The first images I made for this book were of the pilgrimage in honor of La Virgen de Guadalupe in Tortugas, New Mexico. I wanted to make each image a true record of the iconography of Chicano culture. But I found a deeper understanding of what it means to be Chicano further into the project, while making photographs of individuals.

It is my hope these images convey the quiet dignity of a kind and generous people who allowed me to be at once an observer and a participant in their lives.

"You have the face of a gringo," said one, "but you have the heart of a Chicano."

—Robert Kaiser (as told to Nani Kaiser)

PROLOGUE
1. San Diego, California.
2. La Mesa, New Mexico.
3. Albuquerque, New Mexico.

CUANDO VINO EL ALAMBRE, VINO EL HAMBRE
4. Sunland Park, New Mexico, and Anapra, México.
5. Sunland Park, New Mexico, and Anapra, México.
6. Palomas, México.
7. Palomas, México.
8. Sunland Park, New Mexico, and Anapra, México.
9. Juárez, México.
10. Palomas, México.
11. U.S. side of Palomas, México.
12. Imperial Beach, California, and Tijuana, México.
13. Juárez, México, and El Paso, Texas.
14. Palomas, México.
15. Palomas, México.
16. Garfield, New Mexico.
17. Garfield, New Mexico.
18. Garfield, New Mexico.
19. El Paso, Texas.
20. El Paso, Texas.
21. Garfield, New Mexico.

SI DIOS QUIERE
22. La Mesa, New Mexico.
23. Tucson, Arizona.
24. Tortugas Pueblo, New Mexico.
25. La Mesa, New Mexico.
26. Las Cruces, New Mexico.
27. Anthony, New Mexico.
28. Chimayó, New Mexico.
29. Vado, New Mexico.
30. La Mesa, New Mexico.
31. Chimayó, New Mexico.
32. Los Angeles, California.
33. Las Cruces, New Mexico.
34. Las Cruces, New Mexico.
35. Las Cruces, New Mexico.
36. Chimayó, New Mexico.
37. Juárez, México.
38. Los Olmos, Texas.
39. Chimayó, New Mexico.
40. Tortugas Pueblo, New Mexico.
41. Anthony, New Mexico.

DIME CON QUIEN ANDAS . . .
42. Mesilla, New Mexico.
43. César Rosas. Albuquerque, New Mexico.
44. Los Angeles, California.
45. Johnny Flores. Las Cruces, New Mexico.
46. Flaco Jiménez. Las Cruces, New Mexico.
47. Luis Valdez. Prescott, Arizona.
48. Sandra Cisneros. San Antonio, Texas.
49. Rudolfo Anaya. Albuquerque, New Mexico.
50. Canutillo, Texas.
51. Las Cruces, New Mexico.
52. Vado, New Mexico.
53. Hildebrando López. San Isidro, Texas.
54. Vado, New Mexico.
55. Vado, New Mexico.
56. Vado, New Mexico.
57. Dixon, New Mexico.
58. San Antonio, Texas.
59. Mesilla, New Mexico.
60. San Diego, California.
61. Mesilla, New Mexico.
62. Andrew Valverde, Andrew Salas, and Joseph Alfaros. Albuquerque, New Mexico.

MI VIDA LOCA

63. Frank Mendoza and Leo Buentello. San Antonio, Texas.
64. Palomas, México.
65. Los Angeles, California.
66. Julian and Justa Lovato. Santa Fe, New Mexico.
67. Louie Burke and Antonio Escalante. El Paso, Texas.
68. Robert Verdoza. Casa Grande, Arizona.
69. Albuquerque, New Mexico.
70. San Diego, California.
71. San Antonio, Texas.
72. Austin, Texas.

EL NORTE MÁS ALLÁ

73. San Rafael Chapel. La Cueva, New Mexico.
74. Alcalde, New Mexico.
75. Alcalde, New Mexico.
76. Chimayó, New Mexico.
77. Alcalde, New Mexico.
78. Cipriano Vigil. El Rito, New Mexico.
79. Talpa, New Mexico.
80. Tortugas, New Mexico.
81. San José de Gracia Church. Las Trampas, New Mexico.
82. Carlos Barela. Talpa, New Mexico.
83. Ocate, New Mexico.
84. Luis Sánchez. Ojo Sarco, New Mexico.
85. Patricia Quintana. Taos, New Mexico.
86. Nobert Ledoux. Talpa, New Mexico.
87. Belén, New Mexico.
88. Alcalde, New Mexico.
89. Tucson, Arizona.
90. Rio Grande River near Rinconada, New Mexico.

UN PUÑO DE TIERRA

91. Bugs Salcido and Cleopatra Smith. Mesilla, New Mexico.
92. Palomas, México.
93. Palomas, México.
94. Falfurrias, Texas.
95. Socorro, New Mexico.
96. Dixon, New Mexico.
97. Canutillo, Texas.
98. Canutillo, Texas.
99. Canutillo, Texas.
100. Canutillo, Texas.
101. San José de Gracia Church. Las Trampas, New Mexico.
102. Three Rivers, Texas.
103. Piedras Negras, Mexico.
104. Las Cruces, New Mexico

CUANDO LLEGUEMOS

105. Rancho de la Familia Sánchez-García. Zaragoza, México.
106. Rancho de la Familia Sánchez-García. Zaragoza, México.
107. Rancho de la Familia Sánchez-García. Zaragoza, México.
108. Rancho de la Familia Sánchez-García. Zaragoza, México.
109. Palermo, California.
110. San Antonio, Texas.
111. Mesilla, New Mexico.
112. Albuquerque, New Mexico.
113. Reies López Tijerina. El Paso, Texas.
114. Rancho de la Familia Sánchez-García. Zaragoza, México.
115. Rancho de la Familia Sánchez-García. Zaragoza, México.
116. Oroville, California.

EPILOGUE

117. Carlos Luis "Pancho Villa." Tucson, Arizona.

Reconocimientos

The authors are eternally indebted to all the people who took the time to meet and share their lives with us. Without them this book would not have come to fruition. We are grateful for the support rendered by the Fabián and Virginia Samaniego Memorial Scholarship Endowment, the Southwest and Border Cultures Institute, and the College of Arts and Sciences at New Mexico State University. Agradecimientos también a Enrique Lamadrid, Gabriel Meléndez y Miguel Gandert por su apoyo. Aprecios a Bill Sanchez, Sandra Cisneros, and Jeana Rodarte-Romero, who provided us nourishment along the way. We extend many thanks to Clark Whitehorn, Catherine Leonardo, Diana Rico, and the entire editorial team at the University of New Mexico Press, who believed in this project from the beginning. And to all those who gather in the name of community, gracias.

Querencias Series

Miguel A. Gandert
and Enrique R. Lamadrid,
Series Editors

Querencia is a popular term in the
Spanish-speaking world used to
express love of place and people.
This series promotes a transnational,
humanistic, and creative vision of the
U.S.-Mexico borderlands based on all
aspects of expressive culture, both
material and intangible.

Other titles in the Querencias series
available from the University of New
Mexico Press:

*Hotel Mariachi: Urban Space and
Cultural Heritage in Los Angeles*
by Catherine L. Kurland, Enrique R.
Lamadrid, and Miguel A. Gandert.